Fwd: Museums

Fwd: Museums

small
2017

STEPSISTER
PRESS

Cover image by Roni Packer, *Circle*, 2015.
Cover and interior design by Lauren Dacy.
This book was typeset using Blanch and FreightSans Pro typefaces and
is printed on acid-free paper by Ingram Spark.

TABLE OF CONTENTS

ACKNOWLEDGEMENTS

WE would again like to begin the acknowledgments by recognizing the first inhabitants of this land and their contributions. We give thanks to, and honor the strength of, the Chickasaw, Dakota Sioux, Ho-Chunk, Illini, Miami and Shawnee peoples, as well as the Oneida, Ojibwe, Menominee, Sac and Fox, Potawatomi of the north woods, Lakota, Navajo, Blackfoot, and Papago people. We affirm and draw upon the resilience of these and the many other native groups living in and around Chicago, past and present.

We have so much gratitude and praise for the Museum and Exhibition Studies Program at the University of Illinois at Chicago, which encourages resistance to traditional museum beliefs and a radical rethinking of the field. Thank you to Lisa Lee, Anthony Stepter, MUSE and affiliated faculty for all your continued support and enthusiasm for the production of this second issue. A special thank you to Therese Quinn, MUSE Director and *Fwd: Museums* advisor, for always pushing back, and for the guidance you provide us.

We are also so thankful for the hardworking artists, activists, and collectives of Chicago and beyond who persist through trying times and continuously challenge the status quo and produce alternative modes of engagement. We are especially grateful to The Floating Museum Collective for their involvement as this issue's Welcome writer and we are so inspired by the way they have reimagined museums and site-specific spaces.

We are incredibly grateful to everyone who took the time to submit their work and for all the contributors who have made this second issue so special. Thank you to StepSister Press, and especially Annie Heckman and Lauren Dacy, for helping us to create another beautifully designed publication and making the process effortless. We really appreciate all your hard work, input and patience! To the publication team, who took on the impossible task of producing a journal within a single

semester, thank you for everything. Last but most certainly not least, a huge thank you to Sarita Hernández, *Fwd: Museums* Publication Coordinator, for all your persistent dedication, for being such a wonderful leader, and for inspiring this journal to exist and continue on.

PUBLICATION TEAM

Evelyn Yeung
Javairia Shahid
Juhri Selamet
Whitney Scullawl
Therese Quinn
Shannon Ondriezek
Erin Madarieta
Marlo Koch
Sarita Hernández
Shir Ende
Amanda Coleman
Noora Al Balushi
Amara Andrew

LANGUAGE MATTERS
Javairia Shahid

THE stories we tell matter. But perhaps what matters more is how we tell stories. Language does not merely portray the world we imagine, it creates it. In other words, language is constituted of conceptual and discursive referents to think with. We are inclined to think of words as a means of communication, and not to recognize that language first and foremost is a structural device that stratifies our experiences to generate precisely ordered world-views. Simply put, language tells us what things are, and how we may think with and through them. Language is not a neutral medium of expression.

Words as worlds, are reflective of our historically contingent cultural and political circumstances. They bring with them a set of attendant associations and ideations, not all of which are without bias. The idea of race, ethnicity, gender and disability are coded into language the same way they are coded into other forms of expression. Unknowingly, in how we use and employ language, we are becoming participants in discrimination and bias. With this in mind, the essays in this issue of *Fwd: Museums* have been carefully edited to reflect that we are attentive to the importance of language, its effects and affects. We hope this will alert our readers to the importance of words, and foster a deeper appreciation of how easily discrimination and bias can slip into our writing, thinking, and doing.

This is where space begins

A visual essay exploring space,
by Floating Museum

The
Chi-
cago
river
is
156 miles
long, a network of independent waterways connect -
ed for
com -
merce
that
cru -
cially
shaped
the
city.
They
are now
thought
of as the
North,
South,
and
Main
branch -
es. This
in-
cludes
the Calumet
River, which helped
Chicago become
an industrial
center and ex -
tended
the city
south -
ward.

Though
the largest
body of water
in Chicago, the
lake is vestigial. Once
larger body of wa -
it has
current
a significantly
ter amid wetlands,
been largely built over and
used as a depository for industrial runoff,
and the remaining body
of water is in parts seriously hazardous.
Lake Calumet Cluster
incorporates nearby bodies of water
and is currently
the target of
environ -
mental cleanup ef -
forts.

The
oldest in-
stitution in America
honoring African Amer-ican history, founded by
Dr. Margaret Burroughs[1]in 1961, Washington Park. The museum
was started in Dr. Burroughs' home, and when it outgrew her home it was
moved to the old Park District Police building. It will continue to
grow into an additional 60,000sqft of space, the Round House, a remarkable
building that used to serve as a stable.

Step 5:
Swallow your
ego. What you
do isn't nearly as
important as how
you relate to peo -
ple. A mountain is not
a throne. And Black folk
don't climb mountains alone.
Step 4: Mold your peace to a peak.
Don't let it plateau. Lead by example.
Create a path for others to follow.
Step 3: Honor thy mama. Earth. Nature. The Black
woman who made ya. Made her womb a whole
world for you. Nurtured a mustard seed and made
a sunflower bloom. When you need help, ask a Black
woman. No one knows labor like we do.
Step 2: Make space. You are preparing for a self-elevation hike.
Pack light. Leave out things that—and those who—don't serve
you. You are a landform all on your own. Don't you know your roots?
Don't you forget: you're rooted. Groundbreaking. A breathtaking view
of treasure beneath trauma.
Step 1: Don't let anyone tell you what you can't do, Stand firmly in your
truth. Remember who built the pyramids. Remember that when Marga -
ret was pushed to the margins, she became her own borough. We borrow
tomorrows by dreaming. Dream for the sake of the forsaken children. Remind
them to have faith even—or especially—during the crusade.
How to Give Life to a Mountain in 5 Easy Steps by Bella Bahhs[2]

1. Dr. Margaret Burroughs' invitation to the community to donate their own artifacts extends the value of the object to the exchange itself, to the relation between the institution and the people it represents. In this way, the institution is of the people, arising from their own histories.

2. Floating Museum commissioned acclaimed Chicago poet and hip hop artist, Bella Bahhs, to write a piece for the 2017 exhibition, "How To Give Life To A Mountain," at the DuSable Museum of African American History. The poem references DuSable founder Dr. Margaret Burroughs and is in conversation with the DuSable collection.

Floating Museum is a collaborative art project that creates temporary, site-responsive museum spaces to activate sites of cultural potential throughout Chicago's neighborhoods. Our interactive spaces engage local artists, historians, and organizations in events that challenge traditional museum thinking and generate community engagement and conversation.

INTRODUCTION
Sarita Hernández

IT is 2017. Trans and Queer youth are still losing their right to pee in peace. Black lives are still criminalized and murdered. Muslims are still under attack. Indigenous water protectors are still fighting for access to their land and water. Undocumented immigrants are still exploited and facing deportation. Women of color still endure street and state violence. The arts are still defunded. Access to public education is still not valued. Climate change is more real than ever. How are museums, libraries, schools, art centers, cultural centers, organizations, and communities responding at macro, micro, and all the levels in between?

As we transition into the second issue of *Fwd: Museums*, we continue to scream, whisper, and struggle against this political moment and its legacy deeply rooted in the continual project of colonization. Museums and their collections mirror this legacy. *Fwd: Museums* urges a deconstruction, examination, and reimagination of museums and cultural institutions. Initiated by graduate students in Museum and Exhibition Studies at the University of Illinois, Chicago, we started this journal by unraveling *Inaugurations* through introducing a discussion on unpaid internships, visitors of color, and migratory spaces. In this second issue, we reply to *Small* – its value, engagement, marginalization, location, and history within and outside museums.

Our second call for submissions survived the 2016 US presidential election campaign and our review process responded to the continual unveiling of fascism and xenophobia deeply rooted in this neoliberal state – where our journal resides and resists. What also occurred is the continued labor of generations organizing against power and white supremacy.

I constantly see tienditas selling piñatas in the form of "El Cheeto" also known as the US president in neighborhoods across Chicago and beyond.

I stumble on protest stickers and posters demanding sanctuary for those most vulnerable in society.

I witness small arts spaces creating protest banners, exhibitions, and community art making for local and transnational activism.

The "small" is more relevant and vital than ever.

Small and marginalized entities such as local organizations, art and exhibitions beyond the museum, and alternative hxstories persist across generations and continue to rise with rippling waves of strike. Within this issue, contributors engage tensions and triumphs within and outside of museums by addressing issues of value, the objectification of communities, and community-responsive programming. From our contributors, we received varying definitions of small ranging from size to the constant impacts of power, critiques of incarceration, and daily experiences with conceptions of status. This issue is a small sample of the vast amount of work devoted to centering smallness, marginaliza-tion, and hidden stories within critical museum studies and beyond. Al-though issues of incarceration, police brutality, immigration status, and intergenerational trauma are buried by vast institutions of power, there have been and continue to be minoritized, powerful communities that engage, create, and fight these institutional and everyday violences.

It is 2017 and Trans and Queer youth are still throwing Sylvia Ri-vera's and Marsha P. Johnson's heels at the police. Black lives are still creating community-run security and resisting the police state. Muslims are still transgressing borders. Indigenous water protectors are still singing and praying at Standing Rock. Undocumented immigrants are still unapologetic, unafraid, and resilient. Women of color are still not smiling for you. Monarch butterflies still migrate from Michoacán to the Midwest. Public arts education continues to be more necessary than ever. *Fwd: Museums* is actively listening, engaging, and forwarding these critical conversations rooted in the *Small* that started way beyond our inauguration. We invite you to continue listening, creating, and acting in resistance, no matter how small.

SANCTUARY FOR OUR PEOPLE

Your Black Lives Matter

Immigrants, we have no walls

Women, your bodies are your own

Queer/Non-conforming/Trans people, you are seen and loved

Individuals with disabilities, you make us stronger

Muslims, you are honored here

Young people, your voice is powerful

YOU ARE SAFE HERE YOU BELONG

Chicago ACT Collective

Sanctuary Poster by Chicago ACT Collective

VALUE OF SMALL THINGS

THE SOCIETY OF SMALLNESS
A BRIEF HISTORY
Georgina Valverde

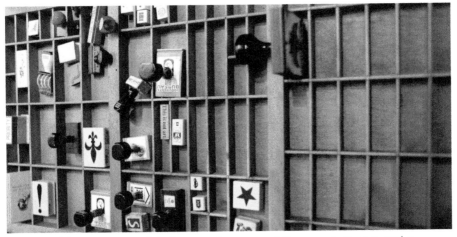

Rubber stamps used during a performance of Documents Bureau at the Chicago Art Department.

SHIT HAPPENED

I am sending you this missive to inaugurate my new drippy, but stain-free logo. It chirps of great things to come—like an anti-corporate, anti-institutional something or other for small beings and things.
—Georgina Valverde to Jessica Hyatt, September 5, 2012

AS we ate in the outdoor sculpture garden at the Art Institute of Chicago, bird poop fell out of the sky. Amazingly, it plopped down on the tiny area encircled between the edge of my plate and my right thumb and index finger, soiling only the napkin on which my hand rested. "This must be a sign!" I announced to Jessica, a fellow artist and colleague at the museum. I kept the napkin with the miraculous poop.

As I was walking from work to the Blue Line train that evening, the idea for the Society of Smallness formed. I had no clear vision of what it would be, but somewhere between Michigan Avenue and Dearborn I

took a detour. A society would need books, accounting, annals—I would use bureaucracy, that intractable network of rules and procedures that governed everything I did at work, to create something all my own.

I scanned the napkin with the dried bird poop on the office copier—it became the first logo for the Society of Smallness. I wrote a brief report about our lunch and forwarded it to Jessica via interoffice mail. She responded as the Society of Containment.[1]

Over the next few days, I taught myself to write in Courier typeface and began making daily entries in a ledger. I set out to record small, everyday things even as they intersected with large-scale ideas and events, as in the following example:

> September 10, 2012
> On my way to the train, I saw many Chicago Public School teachers on strike wearing their red T-shirts.[2] This made me notice all red garments, even those of non-strikers. Small shifts in perception bring out large-scale patterns.

The ledger entries lasted a week, long enough to effectively establish the Society of Smallness as an enduring concept.[3]

TOWARDS A DEFINITION

WHENEVER people ask me what the Society of Smallness is, I turn it back to them, "What does it mean to you?" People create their own interpretations with very little encouragement.

Smallness provokes our imagination because it conjures up inexhaustible options: snowflakes, stamps, subatomic particles, the list goes on. Any of these categories is a world onto itself.

1. Jessica Hyatt to Georgina Valverde, September 13, 2012.
2. Dana Liebelson, "What Happened to the Chicago Teacher Strike, Explained," *Mother Jones*, September 11, 2012, Accessed April 11, 2017, http://www.motherjones.com/politics/2012/09/teachers-strike-chicago-explained.
3. "About," *The Society of Smallness Blog*, last modified July 31, 2016, https://societyofsmallness.com/about/.

Upon learning about the Society of Smallness, a friend of mine organized her version of a "yard sale." It was held in the middle of her kitchen table within a space demarcated by a couple yardsticks. Friends and neighbors trickled in throughout the day to hawk their wares: miniatures, small toys, jewelry, etc.

I believe smallness resonates with people because it is a "generative theme"—in the sense of Brazilian educator and philosopher Paulo Freire's educational theory—a tangible way to grasp the historical processes that unfold during our lifetime.[4]

Smallness also invites a sense of play and intimacy and feels accessible, doable—it helps tame unrealistic expectations. We don't have to be world-class mountain climbers (chefs, artists, etc.)—we can go on hikes and if we end up climbing a mountain, then, hurray! If we don't, at least we didn't stay home moping about not being some fantasy version of ourselves.

BECOMING A SMALL CURATOR

BRAZILIAN artist Ricardo Basbaum christened the brand new gallery at University of Chicago's Reva and David Logan Center for the Arts with an exhibition of his ongoing project titled "Would you like to participate in an artistic experience?"[5] Basbaum presents this open-ended invitation through the constraints of a peculiar metal object that resembles a giant, rectangular bundt cake pan roughly the size of a foosball table. Groups or individuals are allowed to borrow the *NBP* (New Bases for Personality) *object* and take it outside of the gallery space to use it as they please. Basbaum's only request is that participants document their experiences on an online archive.[6]

4. Paulo Freire, *Pedagogy of the Oppressed*, ed. Donald Macedo, trans. Myra Bergman (New York: Continuum, 2000), 8.

5. Monika Szewczyk, "Ricardo Basbaum: Would You Like To Participate in an Artistic Experience?" Logan Center Exhibitions, *University of Chicago*, October 2012, accessed March 22, 2017, https://arts.uchicago.edu/logan-center/logan-center-exhibitions/archive/ricardo-basbaum-would-you-participate-artistic.

6. Ricardo Basbaum, "Would You Like to Participate in an Artistic Experience?" *New Bases for Personality* (NBP) website, accessed April 11, 2017, http://www.nbp.pro.br/.

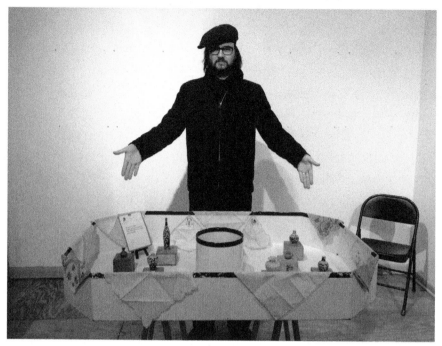

Dieter Roelstraete poses next to "Miniature Asian Ceramics and Portuguese Hankies" exhibited in Ricardo Basbaum's NBP object at Calles y Sueños during the Society of Smallness's Mini-exhibitiothon I

"Why don't you take it?" prodded Dieter Roelstraete, "What would you do?"

Roelstraete was the newly appointed Manilow senior curator at the Museum of Contemporary Art.[7] His partner, Monika Szewczyk, the curator at the Logan Arts Center, nudged me as well. Two internationally known art figures were asking me to play and I said yes.

With less than a month to prepare, I threw myself into organizing the Society of Smallness' first curatorial project, a five-hour marathon of tiny shows inside Basbaum's metal object.[8] I circulated a request for proposals among artists that I knew and hurried to secure a space for the event at the now defunct Casa de Arte y Cultura Calles y Sueños (Streets and Dreams) arts collective in Pilsen.[9]

7. "Dieter Roelstraete Named Senior Curator at the MCA Chicago," *Artforum*, October 31, 2011, accessed March 22, 2017, https://www.artforum.com/news/id=29282.

8. "Inaugural Mini-exhibitiothon and Member Tryouts," *The Society of Smallness Blog*, accessed April 13, 2017, https://societyofsmallness.com/2012/11/04/mini-exhibitiothon-and-member-tryouts/.

9. Daniel Tucker, "Christina Obregón and José David," *Never the Same* (online archive), 2011, accessed March 22, 2017, https://never-the-same.org/interviews/christina-obregon-and-jose-david/.

On November 4, 2012, the Society of Smallness' first "Mini-exhibi-tiothon" kicked off with inaugural rites, appropriately, to an audience of three. Visitors began trickling in, eventually totaling more than thirty. Every thirty minutes, a small exhibition was installed and thirty minutes later, it came down. Altogether, a total of seven shows were exhibited inside Basbaum's object. "Let's Play Canicas" (Let's Play Marbles) invited participants to play a rather anarchic game that devolved into a riotous, sonic experience as children and adults swished marbles around the object. A show of very short videos on cell phones included a loop by musician Fred Lonberg-Holm playing his cello with a strand of hair for a total of six seconds. Artist Jean Sousa displayed a delightful collection of miniature Asian ceramics and Portuguese handkerchiefs in crates and spoke about how the two became tied through the Silk Road.

Midway through the event, Szewczyk and Roelstraete showed up with Ricardo Basbaum in tow on their way from picking him up at the airport.

SOCIAL OBJECTS

> I carry a purse and now I'm going to use it.
> —Meg Duguid, Founder of Clutch Gallery

A friend ran up to me at the 2012 MDW Fair and blurted out excitedly, "You have to see this! Someone is walking around giving gallery tours of a small exhibition inside a woman's purse."[10]

The docent was Jeffrey Grauel and he was carrying Clutch Gallery, a 1970s wooden handbag that has been adapted to house a 25-square-inch gallery.[11] The show was Miniature/Gigantic, an exhibition curated by Slow Gallery's founder and director Paul Hopkin.[12] It was a group show with work by Benjamin Bellas, Judith Brotman, CC Ann Chen, Andreas Fischer, Brent Garbowski, Joe Mault, and Mican Morgan.

Meg Duguid purchased Clutch Gallery on eBay for $5.00 in 2009. She sanded it to remove the decoupage images of strawberries that

10. "Announcing MDW Fair," *MDW Fair,* posted September 18, 2012, http://mdwfair.org/.
11. *Clutch Gallery Blog,* last modified March 24, 2017, https://clutchgallery.blogspot.com
12. "Miniature/Gigantic," *Clutch Gallery Blog,* accessed April 13, 2017, http://www.clutch.gal-lery/2012/10/miniaturegigantic.html.

decorated the exterior and built walls inside to create a gallery space and side compartments for her wallet, keys, cell phone, and birth control.[13] Late in 2012, I met with Duguid at New Wave Coffee in Logan Square to discuss a six-month trial period during which I, as the Society of Smallness, would take over curatorial duties. I ended up programming Clutch Gallery for over two years.

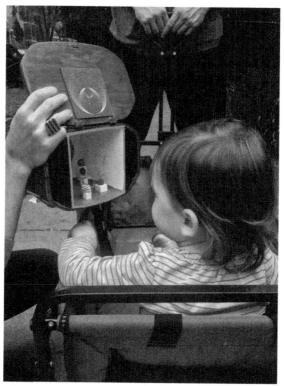

A baby on the street peers into Clutch Gallery featuring "Your Eye is My Ear(lobe)" by Laura Davis

Until one starts carrying Clutch Gallery as a purse, it is difficult to fully appreciate the extent of Duguid's visionary idea. Clutch Gallery creates opportunities to disrupt, ever so minutely, very ingrained expectations and opens up possibilities for conviviality. In this sense, Clutch Gallery is what audience engineer and museum participation expert Nina Simon calls a "social object."[14]

Clutch Gallery is small but has a big impact on praxis. Clutch Gallery is accessible, even when the artwork is not, like Erin Washington's Unti-

13. MartinJon Garcia, "Clutch Gallery: From Fashion Accessory to Art Gallery," posted September 2010, https://youtu.be/rbFAsXXcUBg.
14. Nina Simon, "Chapter 4: Social Objects," in *The Participatory Museum*, accessed March 21, 2017, http://www.participatorymuseum.org/chapter4/.

tled (aerophyte) of 2014, which used air plants and Mylar to reference Walter de Maria's 1977 New York Earth Room.[15] Everyone wants to peer inside a closed box. Even the most blasé person is vulnerable to this provocation. I once showed it to a couple of hard-boiled Chicago cops who could not resist. They wanted to look even as one of them warned, "It better not be a bomb."

Clutch Gallery allowed me to test and explore the generative nature of Society of Smallness in a structured and disciplined way. Every month, I was responsible for selecting an artist, writing a press release and pithy statement about the show, and preparing and restoring the gallery walls before and after an exhibition. I met new artists, especially those associated with Slow Gallery with whom Duguid is affiliated.

Running Clutch Gallery and representing the Society of Smallness opened many doors in the art community that were previously inaccessible or unknown to me. Working at the museum, I was in close proximity to the School of the Art Institute of Chicago (SAIC). Through this association, I initiated several partnerships. Working with the manager of special collections at the Joan Flasch's Artists' Book Room, I organized lunchtime lectures for Clutch artists. For two years in a row, I collaborated with Rhoda Rosen and her Contemporary Cartography class at SAIC. Her students curated two group exhibitions for Clutch Gallery and produced catalogs.[16] Henry Harrison, one of her students, became a close collaborator.

15. "Untitled (aerophyte)," *Clutch Gallery Blog*, accessed April 13, 2017, http://www.clutch.gallery/2014/05/untitled-aerophyte-by-erin-washington.html; "Walter de Maria, *The New York Earth Room*," *Dia:*, accessed April, 13, 2017, http://www.diaart.org/visit/visit/walter-de-maria-the-new-york-earth-room-new-york-united-states.
16. Rhoda Rosen, "41.8757° 87.6244°," *The Society of Smallness Blog*, published November 29, 2013, https://societyofsmallness.com/2013/11/29/41-8757-87-6244/.

RISE OF A BUREAUCRACY OF INTIMACY

This stamp was designed for the Society of Smallness' second
Mini-exhibitiothon, a day-long program of exhibitions and events held
in the nooks and crannies of Georgina Valverde and Matt Stone's
Humboldt Park home

BY early 2013, the Society of Smallness was a well-established project. Through Clutch Gallery, we were invited to participate in 2nd Floor Rear, an annual DIY art festival organized by Katie Waddell and held in storefronts, apartment galleries, and experimental spaces along Chicago's Blue Line.[17] Showing in Clutch Gallery were Alexis Petroff's tiny *Tape Collages* held together on rolls of clear tape and models for his *Floating Drawings* (actually wall sculptures) made with wire and silk.[18] A coterie of friends and four high school art students accompanied me in roving among the festival venues with Clutch Gallery in hand.

Our event was titled "Unsuspicious Activity Around an Attended Package" and in addition to Clutch Gallery, we also carried a portable typewriter, which we used as an improvisational tool everywhere we went, including while riding the Blue Line and on the platform. At a noodle shop in Wicker Park, we issued an unsolicited pardon to an employee that broke a glass.

17. Katie Wadell, "More About—Participants and Events," *2nd Floor Rear Festival*, February 9-10, 2013, https://2ndfloorrear.org/2012-2015/more-about-2013-participants-and-events/.
18. "Floating Drawings," *Clutch Gallery Blog*, accessed April 13, 2017, http://www.clutch.gallery/2013/02/floating-drawings-by-alexis-petroff.html.

My husband and collaborator, Matt Stone, designed a Society of Smallness logo featuring a shrimp. He made it into a stamp and we used it to lend some credibility to our random quasi-bureaucratic services. We stamped festival programs, napkins, body parts, and a passport.

Over the past three years, these improvised performances have evolved into a full-fledged project titled Documents Bureau, a playful, participatory simulation of office rituals that quicken meaningful interpersonal exchanges.[19] The scale of the performances range from one to sometimes twenty people, mostly volunteers, in the role of clerks and other functionaries who collaborate with the public to produce documents. We have issued over five hundred documents to date—certificates, licenses, affidavits, etc.—and in their production, perfect strangers came together for brief moments of humor, imagination, and intimacy.

In a post-industrial age riddled with formidable problems of overpopulation, resource scarcity, and environmental degradation, smallness invites us to reimagine the way we interact with our environment and each other. With respect to art and its distribution, smallness proposes strategies for engagement that foreground direct experience, accessibility, and a low bar for participation.

According to Paulo Freire, an epoch "is characterized by a complex of ideas, concepts, hopes, doubts, values and challenges in dialectical interaction with their opposites striving towards their fulfillment."[20] Put simply, we don't live in a vacuum—we are either shaped by or actively shape our social context. Our ability to recognize and critically examine generative themes influences our engagement and participation in society and exposes spaces of resistance.

A focus on smallness led me to engage critically, yet playfully, with the narratives that dominate our epoch. Politics of smallness, vulnerability, and intimacy feel like the appropriate antidote for the challenges of globalization, rampant growth, and the gargantuan.

19. Nat Soti, "Documents Bureau Makes it Official," *Inpoints*, June 2016, http://inpoints.org/index.php/2016/06/10/documents-bureau-makes-it-official/.
20. Freire, 101.

BIBLIOGRAPHY

"About." *Society of Smallness Blog, The*. Accessed April 13, 2017. https://societyofsmallness.com/about/.

"Announcing MDW Fair." *MDW Fair*. Posted September 18, 2012. http://mdwfair.org/.

Basbaum, Ricardo. "Would You Like to Participate in an Artistic Experience?" *New Bases for Personality (NBP)* website. Accessed April 11, 2017. http://www.nbp.pro.br/.

Clutch Gallery Blog. Last modified, March 24, 2017. https://clutchgallery.blogspot.com/.

"Dieter Roelstraete Named Senior Curator at the MCA Chicago." *Artfo rum*, October 31, 2011. https://www.artforum.com/news/id=29282.

"Floating Drawings." *Clutch Gallery Blog*. Accessed April 13, 2017, http://www.clutch.gallery/2013/02/floating-drawings-by-alexis-pet roff.html.

Freire, Paulo. *Pedagogy of the Oppressed*. Edited by Donald Macedo, translated by Myra Bergman. New York: Continuum, 2000.

Garcia, MartinJon. "Clutch Gallery: From Fashion Accessory to Art Gallery." YouTube video, 4:51. Posted by "ChicagoArts," September 21, 2010. https://youtu.be/rbFAsXXcUBg.

Hyatt, Jessica. Jessica Hyatt to Georgina Valverde, Chicago, IL, September 13, 2012.

"Inaugural Mini-exhibitiothon and Member Tryouts." *Society of Smallness Blog, The*. Accessed April 13, 2017. https://societyofsmallness.com/2012/11/04/mini-exhibitiothon-and-member-tryouts/.

"Miniature/Gigantic." *Clutch Gallery Blog*. Accessed April 13, 2017, http://www.clutch.gallery/2012/10/miniaturegigantic.html.

Liebelson, Dana. "What Happened to the Chicago Teacher Strike, Explained." *Mother Jones*, September 11, 2012. Accessed April 11, 2017. http://www.motherjones.com/politics/2012/09/teach ers-strike-chicago-explained.

Rosen, Rhoda. "41.8757° 87.6244°." *Society of Smallness Blog, The*. Published November 29, 2013. Accessed April 13, 2017. https://so-cietyofsmallness.com/2013/11/29/41-8757-87-6244/.

Simon, Nina. "Chapter 4: Social Objects." In *The Participatory Museum*. Santa Cruz: Museum 2.0. Accessed March, 17, 2017. http://www. participatorymuseum.org/chapter4/.

Soti, Nat. "Documents Bureau Makes it Official." *Inpoints*. June 2016. Accessed April 13, 2017.http://inpoints.org/index.php/2016/06/10docu ments-bureau-makes-it-official/.

Szewczyk, Monika. "Ricardo Basbaum: Would You Like To Participate in an Artistic Experience?" Logan Center Exhibitions, University of Chicago, October 2012. Accessed March 22, 2017. https://arts. uchicago.edu/logan-center/logan-center-exhibitions/archive/ricar do-basbaum-would-you-participate-artistic.

Tucker, Daniel. "Christina Obregón and José David." *Never the Same* (online archive), 2011. Accessed March 22, 2017. https://never-the-same.org/interviews/christina-obregon-and-jose-david/.

"Untitled (aerophyte)." *Clutch Gallery Blog*. Accessed April 13, 2017, http://www.clutch.gallery/2014/05/untitled-aerophyte-by-er in-washington.html.

Wadell, Katie. "More About—Participants and Events." *2nd Floor Rear*. February 9-10, 2013. Accessed April 13, 2017. https://2ndfloorrear.org/2012-2015/more-about-2013-participants-and-events/.

LIFE IN MINIATURE
AN ODE TO THE THORNE ROOMS
Elizabeth Lalley

I haven't visited the Thorne gallery since I was a child. Today, as I enter, I find it invites that same unguarded enthusiasm of childhood, no matter one's age. The gallery is crowded, the air buzzing with the voices of old and young alike. People bustle about from diorama to diorama. Many visitors are stooped over the miniature rooms, which depict American and European interiors that span the centuries, and bring their noses precariously close to the protective glass. Others shift from side to side in order to view the rooms from every angle. Meanwhile, the glass remains a resolute barrier, and we—the rooms' eager admirers—are left feeling like we can never get close enough.

It seems appropriate that Mrs. James Ward Thorne (1882-1966), who conceived of the project and oversaw the construction of each room, began collecting miniature furnishings when she herself was a child. Yet this fascination with miniatures is not bound to youth. I watch a grown man next to me lean so close to the glass, that his nose leaves a smudge. Could it be that he and I are both imagining ourselves roaming through the tiny scenes—picking up tiny violins, sleeping in miniature beds?

The details of each room, each constructed on the scale of one inch to one foot, are impeccable. Tiny paintings hang on the walls—replicas of actual artworks from the periods depicted. Even the ceilings are artfully constructed. Tiny woven rugs adorn many of the floors. In most of the dioramas, doorways open onto additional rooms, giving us a peek further into the house. Backdrops painted with startling precision are visible through the windows and doorways of many of the rooms, often providing glimpses of a city street or rolling field off in the distance.

The quality of lighting changes from scene to scene. In an ornate New York parlor from the late 19th century, heavy drapes leave the room

largely shadowed and subdued, while light is allowed to flood the high windows of a Tudor period great hall, filling the cavernous space. The varying qualities of light reinforce the distinct personalities of each room. Each is a vivid world unto itself, and with every encounter, viewers have the chance to imagine themselves in a different time and place, living many different lives.

Immaculately furnished, the miniature rooms appear to be missing only one thing: miniature occupants. In the dining rooms, the tables are set and seem to await the arrival of tiny guests. A sense of expectancy hangs in the air. Observing the absence of life in the rooms, we begin to project our own lives into them. The exhibits seem to invite our participation in this way, as though the thing that's missing can be found in the collaboration between our imaginations and the tiny spaces themselves. At one point, I hear a woman murmur to her friend: "I've always wanted a canopy bed...."

I linger in front of a Cape Cod living room, c. 1750-1859. The room is warm and inviting. I lean in close to the glass in order to peer through a doorway on the right, which leads to a tiny foyer. I catch a glimpse of roses cascading over a trellis in a garden. The sea is visible, off in the distance and I imagine the sound of seagulls and the scent of briny air. As I study the room's winding staircase and wonder what the rooms upstairs might look like, I realize that there *is* no upstairs. No sea in the distance. The scene—like all the others—invites possibility, thoughts of comings and goings, and I've become an eager participant in bringing it to life.

Other than providing a description of the room's location and time period, the gallery leaves interpretation up to the viewer. This makes the experience a visually rich and personal one. Making my way around the gallery, I overhear people discussing memories of childhood dollhouses, their own design preferences, and even ideas for their own remodeling projects. The tiny rooms, in their quiet elegance, act as mirrors for our dreams, memories, and aesthetic possibilities. As we peer into these miniature worlds, we may see *ourselves* from a new perspective, if only for a moment.

FRESH THEFT: CONSUMING ART

Yasmin Zacaria Mitchel

I never thought I could feel pity for a thief that claimed not to know better.

One phone call...

PS: Public Safety.
YM: Hi. It's the DePaul Art Museum. A man just stole a piece of a sculpture!
PS: How long ago?
YM: 5 minutes.
PS: What did he look like?
YM: Um, a gray sweatshirt, khakis, sneakers. He was about 6' 2", older maybe 50s.
PS: And race? Black, White, Hispanic?
YM: He was White.
PS: What did he take?
YM: A cigarette.

IT is a Sunday afternoon in early October, around 4:30pm, a half hour away from closing. The DePaul Art Museum sits a few feet away from the Fullerton "L" stop, nestled beside old cobbled brownstones. The newest exhibition, *On Space and Place,* has drawn in visitors from all over the world, and sometimes I find them to be more interesting than our display of contemporary art. I am in the main floor gallery, watching over the space themed "Identity and Social Violence." I am tired and my

eight-hour shift is dragging. I run through the contents of my refrigera-
tor in my head, wondering what to make for dinner; its shelves are prob-
ably as empty as the gallery. It is quiet, save for the rattling of the Nick
Cave *Sound Suits*. The soft rustling of plastic buttons and abacus beads
fill the empty spaces of the gallery and my mind. I check my phone:
twenty-five more minutes. I check my phone: no notifications.

Three visitors, none with relation to each other enter the space:
an older woman, decked in pearls and a long black coat; and two men,
one in a gray hoodie sweatshirt the other in a leather jacket. Demo-
graphics have always fascinated me. Since this museum has no admis-
sion fee, the diversity of our visitors is apparent; everyone from Lincoln
Park moms to the homeless can stop in. One man gravitates towards
the *Sound Suits;* the other towards Tala Madani's *Sainted*. The woman
moves towards me. My primary job as a gallery monitor is to watch over
the space and protect the art, but I am also a brain to be picked. Soon I
am answering questions about the museum. It was built in 2011. Yes, we
take donations. No, this exhibition does not feature DePaul students. As
I continue through the interrogation, I have an eye on the other visitors.
One man makes his way to the room themed "Fact or Fiction," the oth-
er is still entranced with *Sainted*.

The interrogation continues. Yes, I enjoy working here. No, it's not
my only job. I notice hoodie man circling *Spearmint/mouse*, a Liz Ma-
gor sculpture that includes a blue crystallized rock as a podium for an
ashtray balanced on a pack of gum. A plaster mouse lays dead in the
ashtray, covered in cigarette ash. I turn back to finish answering the
woman's questions, telling her to please make sure to visit the
second floor.

She departs, leaving me to ponder hoodie man and *Spearmint/
mouse*. I turn back to him and it looks like he has just touched the
piece. I give him a questioning look and he exits the space. As he walks
past me, I notice he has a tinged cigarette behind his ear. I walk over to
Spearmint/mouse and realize he has taken the cigarette.

I run to the front of the museum and hoodie man is talking non-
chalantly with the other gallery monitor at the receptionist desk.

"Excuse me, sir," I say, "did you take the cigarette from that piece?"

"No."

He books it. Runs north down Fullerton, away from the museum, away from the train. So much is running through my mind. Why now? Why a cigarette? Why a cigarette from an art piece?

Nevertheless, we have to follow protocol. I tell the other gallery monitor to call our Collections Manager. I get on the phone with Public Safety. I can't imagine there is any chance of catching him. After all, it's a white man with a cigarette... in Chicago!

Fifteen minutes go by and a Public Safety Officer walks into the museum. She pulls out a spiral flip book and asks me the same questions as the officer on the phone. As I am giving her the details, hoodie man walks past the museum. I quickly point him out, again describing his crinkled khakis and gray sweatshirt. The officer rushes out and walkies for back up. She trails fifteen feet behind him as he continues past the train down Fullerton.

Fifteen minutes until closing, but there is no way I am getting out in fifteen minutes. The other monitors and I begin shutting down the TVs and inspecting the space. Another Public Safety Officer comes in and asks to see where the incident occurred. I grab our exhibition pamphlet and walk him to the space. I point out the sculpture, the blue quartz shines the same way, as if the adorned ashtray still contains its cigarette. I remark that I doubt we'll be able to prove that the guy took the cigarette.

"Oh, we caught him. He threw his hands up over his head and admitted it, said he smoked it."

I take a step back. A part of me wishes hoodie man did not get caught. I almost regret pointing him out as he sauntered past the window. I wonder how strong the pull of nicotine is. I could only imagine the addiction. How easy it seemed, to inhale and exhale. There's true immediate gratification, I think.

This crime is so petty and so needless. The officer asks if I could give a witness statement to the Chicago Police Department. I doubt I have a choice.

As an aspiring visual arts professional, this ordeal has been difficult to shake off on both a practical and moral level. In our society, it is generally accepted that stealing is against the law. And, those who are caught stealing are expected to be prosecuted. This equally applies to the museum world.

What frustrates me is the worth we place on objects we deem art. If this man had stolen a cigarette from a convenience store, how would the consequences differ? He would be arrested either way. But what then? Why do we place worth on everyday objects that are incredibly mundane? I understand there is inherent worth in an object because of production and labor costs. But I continue to struggle with the concept that we can increase the worth of everyday objects by altering their location. Placing a cigarette in a museum makes it almost priceless, whereas placing it in a store makes it accessible.

Once the Public Safety Officer finishes arming the building, he escorts me down the street to where hoodie man is cuffed and leaning on the side of the Whole Foods storefront. He is surrounded by four Public Safety Officers and one informs me that Chicago PD is on its way. Hoodie man looks amused, with a wrinkled smile and shrugging shoulders.

He sees me approaching and straightens. "Geeze, ma'am. I'm sorry for the trouble. Can you forgive me? I didn't know I couldn't take it."

I ignore him, trying to make sense of what's transpiring around me, trying to maintain composure. Bottom line: hoodie man committed theft. Everyone knows the number one rule is no touching, very few even think of taking.

Among the first questions Chicago PD asks me is if I know the worth of the cigarette. Is it a real cigarette? What brand of cigarette was it?

I didn't have the answers, but hoodie man did. First, he said he was sorry. Then he said it had been "fresh." The cigarette had been exposed on the sculpture for the past couple of months, so I doubted its crispness. But this word — *fresh* — stuck with me.

Hoodie man experienced the sculpture in a way no one else ever would.

SMALL THINGS WITH GREAT LOVE
AN ART DEPARTMENT - LIBRARY EXHIBITION INITIATIVE
Jane Darcovich

IN fall 2015 I collaborated with a studio art professor to create a small exhibition of her students' work at the University of Illinois at Chicago (UIC) library, where I am the Liaison Librarian for Art and Architecture. The exhibition showcased the major semester project of an undergraduate art class – artistic interventions on an existing book employing techniques including drawing, painting, cutting, and collage. As an academic research library, we have an extensive history of presenting scholarly exhibitions in conjunction with our Special Collections Department, and the presentation of student artwork in our library's spaces is ripe for development and expansion[1] as we reimagine the library's role in the 21st century academic community.

Literature discussing exhibitions of student artwork in academic library settings describes both enhanced pedagogical outcomes and the transformative nature of interdisciplinary collaboration. A project carried out at four universities in Australia situates the mounting of student art exhibitions within the sphere of public pedagogy, "a concept that explores the learning opportunities made possible through different processes and spaces of education being offered outside formal schooling, for example in institutions such as museums and libraries"[2] and one that emphasizes the experience of the learner. Other practitioners who created student art exhibition programs in collaboration

1. A notable annual exhibition featuring work by UIC graduate students is *The Image of Research*, organized in conjunction with the Graduate College and held in our library. This juried exhibition celebrates its tenth anniversary this year, 2017. The work of previous years' winners and finalists is viewable at http://collections.carli.illinois.edu/cdm/landingpage/collection/uic_ior
2. Anne Hickling-Hudson and Erika Hepple, "'Come in and look around.' Professional development of student teachers through public pedagogy in a library exhibition," *Australian Journal of Adult Learning*, 56:4 (2015): 445.

with college libraries highlight outcomes of increased student engagement, opportunities for the library and Art Department to broaden their network of relationships across campus, as well as new pedagogical opportunities for both.[3]

Though literature on this topic typically discusses library outreach efforts to faculty in other campus units[4], in this case we were fortunate to have an art professor initiate the collaboration, proposing an exhibition of her student-created artists' books in the library. Immediately we sensed that this was a great opportunity to explore an innovative type of cross-disciplinary collaboration.

The seventeen undergraduate students in the class worked with used books they had selected and purchased on their own. They each chose a variety of materials and techniques to create drawn, painted, cut, sewn, and collaged interventions in their books to highlight concepts they wished to explore or issues they wished to confront, sometimes incorporating ideas from their recent artistic explorations.

The books chosen were significant in a variety of ways – many reflected personal experiences and memories. One student selected an ethnic cookbook written in her native language that her grandmother had used, representing ties to her culture and family. Another chose a book about a personal hero, Billy Williams, an African-American Major League Baseball player. Others selected books to serve as metaphors for life situations or to address societal issues such as domestic violence.

Each participant submitted a statement discussing the artistic interventions they employed along with comments about the concept, issue, or situation brought to the fore by their interventions. One student described the process of changing her book *The Personality of the Cat* from its original subject to become a reflection on her journey to self-acceptance. Her artistic interventions included emphasizing words

3. Astrid Oliver, "Strengthening On-Campus Relationships via an Annual Student Art Commission," *Journal of Library Innovation*, 3:2 (2012): 94.

4. See Megan Lotts, "Building bridges, creating partnerships, and elevating the Arts: The Rutgers University Art Library Exhibition Spaces," *College & Research Libraries News*, 77:5 (2016): 226-230.

and phrases in the text with black ink, adding watercolor painting and collaged paper directly on the pages of the book, and stitching together sections of page edges with twine (Figure 1).

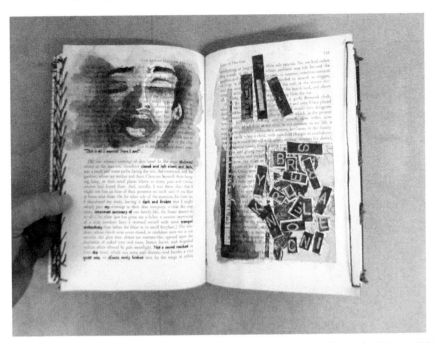

Figure 1: Interior page spread, artist's book by Sarah Lauer, 2015. Photo by Dianna Frid.

The exhibition was held in an open area on the second floor of the library near the top of a set of escalators, a space that afforded good visibility and that benefitted from foot traffic in the area. No lockable room or other form of security was available, so being able to secure the artwork in locked display cases was a necessity. These logistical considerations also imposed some restrictions on the overall dimensions of each piece. There were also budget constraints in place, and whenever possible existing equipment and supplies were used. The exhibition was mounted using three lockable display cases owned by the library, along with plexiglass book cradles and stands lent by its Special Collections Department.

I worked with a staff member in the Special Collections Department to design, print, and mount a wall sign and descriptive label cards for the display. The sign announced the exhibition title *"Book Invasion!"*, along with the class name and professor's name (see Figure 2). The

exhibition layout and installation was accomplished with the professor, a graduate assistant from the Department of Art, and me. After the placement of the books was determined, each label card with the student's statement was placed adjacent to its corresponding book.

Despite its small scale, the exhibition accomplished goals greater than its modest physical presence would suggest. One of these accomplishments occurred during the opening reception, held during the regularly scheduled class period so that all class members could attend. Another undergraduate art class, Signifying Practices, attended the event. More than just a social event - with cheese, fruit, and beverages provided to celebrate the occasion - the reception was transformed into an engaging educational experience for the students, with many of the exhibition participants speaking to the assembled group about the process of creating their artists' book and what impact it had on them. For the students in the Signifying Practices class, hearing about the decisions made and the creative processes the artists went through provided an added dimension to their visual experience of the exhibit.

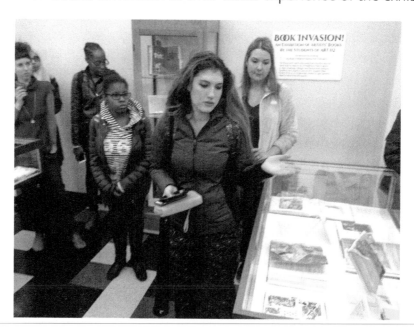

Figure 2: Student participant speaking about her artist's book at the *Book Invasion!* exhibition opening, November 18, 2015. Photo by Dianna Frid.

Creating an exhibition of the students' artwork helped increase the value of the book intervention project, making each piece more than an assignment to be viewed and evaluated by the professor alone, but an artwork with a life beyond the classroom, reaching out to and viewed by a broader audience, including their student peers.

The exhibition presented advantages for the library as well. Many of the participating students were not regular visitors to the library, and the display of their artwork in this space over a period of weeks broadened their definition of what the library could offer them. One of the students asked whether the library was open on weekends, and if he could bring his parents to view the exhibition. The answer to both questions was an enthusiastic "Yes!"

Cultural heritage and digital library experts Waibel, Zorich, and Erway understand collaboration as a process that, with needed catalysts, occurs along a continuum from initial contact through cooperation and collaboration, to convergence.[5] Having presented this student art exhibition only once, our university library is at the "co-operation" stage of this continuum. We do have several of the identified catalysts in place, however, which will help maintain and expand this new effort. The library's strategic plan embodies the "vision" catalyst, with the goal of "partnering with faculty in teaching, research, and practice" as part of its mission, under the guiding value of user-centeredness, and in concert with "creating spaces that promote research, learning, and collaboration".[6] Incentives are present for me and other librarians to continue this work, as it is considered an integral role of a liaison librarian (the "mandate" and "incentives" catalysts). The recent establishment of a library Exhibitions Committee that documents efforts in this area and provides criteria and guidance for selecting exhibitions fulfills the role of the "mooring" catalyst.[7]

5. Günter Waibel, Diane M. Zorich, and Ricky Erway, "Libraries, archives and museums: Catalysts along the collaboration continuum", *Art Libraries Journal*, 34:2 (2009): 17

6. The 2016 University Library strategic plan is openly available at https://uofi.app.box.com/s/6sitsnigu9jx9nld2j67lslmwob7toqi

7. A descriptive list of all collaboration catalysts is provided in Waibel et al., "Libraries, archives and museums: Catalysts along the collaboration continuum," 19.

In the future, I envision the exhibition becoming part of an ongoing collaborative library exhibition program, building on its genesis as a stand-alone event. Expanding the number and variety of exhibitions held at the library will help transform its role, as well as impact pedagogical practices in the Department of Art. Reflection and assessment is necessary to ensure that the collaborative relationship continues to be beneficial for all parties.

Steps towards achieving these larger goals include increasing collaboration with Signifying Practices or another similar class, by incorporating student-written critical or creative pieces related to the exhibition that could be used in library news articles and promotional materials.[8] Working with the Library's Exhibits Committee and creating documentation to ensure that any future art liaison librarian could build on the precedent for collaborative exhibitions is another step in ensuring the vitality of this program.[9]

Given the success of the initial exhibition, another artists' books exhibition is planned for the current (Spring 2017) semester.

WORKS CITED

Burton, David. "Exhibiting Student Art." *Art Education,* 57(6) (2004): 41-46.

Hickling-Hudson, Anne and Erika Hepple. "'Come in and look around.' Professional development of student teachers through public pedagogy in a library exhibition." *Australian Journal of Adult Learning,* 56(4)(2015): 443-459.

Lotts, Megan. "Building bridges, creating partnerships, and elevating the Arts: The Rutgers University Art Library Exhibition Spaces." *College & Research Libraries News,* 77(5) (2016): 226-230.

8. See David Burton, "Exhibiting Student Art," *Art Education,* 57:6 (2004): 43
9. Astrid Oliver, "Strengthening On-Campus Relationships via an Annual Student Art Commission." 93.

Oliver, Astrid. "Strengthening On-Campus Relationships via an Annual Student Art Commission." *Journal of Library Innovation*, 3(2) (2012): 89-104.

Waibel, Günter, Diane M. Zorich, and Ricky Erway. "Libraries, archives and museums: catalysts along the collaboration continuum." *Art Libraries Journal*, 34(2) (2009): 17-20.

A CONVERSATION BY THE LOO
ON SMALL ARTIST-RUN SPACES
Noora Al Balushi with Paul Hopkin and Jeffrey Grauel

IN a predominantly Latinx neighborhood in Pilsen, Chicago, a former hair salon has been transformed into an art gallery. Slow Gallery, is owned and directed by Paul Hopkin. In Hopkin's recollection of the gallery's early days, neighbors curiously passed by, peering in to view what the space had been transformed into. What seemed to appear as large garbage bags hung from the ceiling, Hopkin would invite people in to see, was part of the show. As time passed, more and more artists from the neighborhood began showcasing their art in Slow Gallery, as Paul, an artist himself, offered a new art space for young and emerging artists in Pilsen.

My first visit to the gallery was upon a coincidental encounter with Jeffrey Grauel, a friend of Hopkin's and Slow's co-director. In describing the space, Grauel explained how within the larger gallery lies a smaller one, called The Loo Gallery. The reason for the title is simple: the gallery is, indeed, in the bathroom. As a gallery space encompassing no more than 25 square feet, and only comfortably fitting one or two people at a time, The Loo had been chosen by NewCity in 2014 as one of the "Top 5 Art Spaces in Tiny Places."[1] As it comes to be, Grauel is the gallery's director, officially the Director of The Loo.

As artists and curators, how do you differentiate between your roles?

Paul: That's a really hard thing because in my mind I don't really separate them. I don't like the idea that a curator is above the position or

1. Morris, Matt. "Newcity's Top 5 of Everything 2014: Art." NewCity. 2014. Accessed November 01, 2016. http://art.newcity.com/2014/12/24/newcitys-top-5-of-everything-2014-art/.

an advancement beyond being an artist. That really bothers me. I think that plays a role of me not caring what you call me because I certainly curate, and I certainly have an investment in that, but I don't feel like my point of view is in any way above or any sort of an overseer of the artist. We have to work together.

Jeffrey: I agree in some sense. I think in my mind I draw a line between curation and my art practice, especially with the bathroom gallery. I intentionally become a curator and intentionally remove all of my artistic impulses, but it's all in my head. I don't think it's something I'm accomplishing, but in my head I try to make this delineation between my art practice and me being a curator.

The Loo Gallery is still a functioning bathroom. How does the artwork presented within relate to the humor behind that fact?

Jeffrey: With the bathroom, it's not a stand-alone thing. You can't get away from the fact that you're in a bathroom, which is ridiculous in itself. You cannot get away from the fact that it is a gallery within another gallery; you're experiencing one show within another. There is the joke of The Loo itself being a bathroom, but the topics brought up inside aren't that light. Because if it's all completely a joke, you can discount the ideas presented within it really easily.

Paul: I agree. The humor is inevitable, and one would think carefully about the art work that goes in there, or it undermines everything. It can backfire and make it feel like all of the art presented within is merely a joke. But as I see it, addressing difficult topics comes easier with humor as it does with art. Something I will never forget is my encounter with the book Ghost in The Machine, a philosophical book by Arthur Koestler written in the 60's that talks about laughter. The thing is, laughter is associated with other emotional responses, you get scared, anxious, disturbed, and your body enters into flight or fight mode. When you're in fear, you make a joke and it reduces your fear. Same with dealing with arousal, you are drawn to someone and then realize, shit, it's my cousin. Joking about that, laughing, dissipates those feelings.

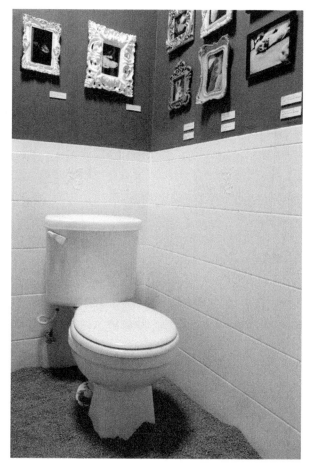

Loo Gallery's show "Litterall", photography by Michael Weinberg.

In that sense, what is an example of a show in The Loo that related to a multi-dimensional topic related to No. 1's, and No. 2's?

Jeffrey: Well, in one show I invited Jessica Hannah, an artist and perfumer. It was a perfect place for her to work on perfume, as the fact is in that in every perfume there is an ingredient that is simply disgusting. There's fecal matter, and there's urine or civet, which is the urine of this one cat. Another example is ambergris, which is a substance whales digest and puke out into the ocean to ferment. For generations people have fought over this ingredient because, as it seems, adding it into perfume adds a depth that makes the smell immensely intriguing. As part of her show, Jessica made three panels where the top, middle and lower

note of perfume was added, and because they were made of carpet, the cloth collected molecule throughout the day, and the perfume that was once there had the scents of everyone who entered the bathroom added to it. So, on the course of the show, the scent became deeper, richer, and denser.

In the NewCity list '5 Small Art Spaces' in which The Loo Gallery was mentioned, other small artist-run spaces have been mentioned. The humor behind each space is unavoidable. What are your thoughts on that?

Paul: The parody in these small artist-run galleries is part of a greater Chicago-linked character and humor. Other examples are The Trunk Show by Raven Ralquez Munsell and Jesse Malmed, which is an art space in the trunk of a 1999 Ford owned by the curators. As it travels around Chicago, and parks usually near Chicago's Eckhart Park, the trunk opens to reveal, not a dead body, but artwork. Another example is The Clutch by Meg Duguid which has been circulated and given to different artists to curate and carry. I curated a show in there once. It's this 25 square-inch clutch and art gallery. There was also Trench Coat back in the late 90's. Jesse Berkowitz made a show based on a cultural reference to a fence, a shady man waiting for you to pass him, for him to open his coat and show you stolen goods, but in this case, the guy leans in towards you, opens his coat and asks "Psst, wanna see some art?"

It seems a lot of artists in Chicago deal with humor, or even dark humor in their work. Where does the humor come from?

Paul: It's a way to say something that could otherwise be difficult or combative to say. Chicago has its own kind of vibe. It's a cheap city so that's good for artists, and it has a good art school, so those two factors bring people to the city. While there's a critical mass of interest and people, Chicago is really impoverished in terms of the likelihood of making a living off of your art, there's not a whole lot of that going on in this city. There's far more people who are doing it at their own expense rather than getting paid for the work that they do, and I think

that's where the humor comes in. If you are a normal person at some point it all registers as anger if you're being screwed over, and we are all screwed over. The system is stacked against us in some way, and something's wrong with you if you're not angry when you're screwed over, something's really wrong with you. People are afraid of anger, but anger is a healthy response to a situation much of the time, and when the system is rigged. When you gain an art education it's exorbitantly expensive and the likelihood of earning a dollar for your education is very low so why wouldn't you be pissed off? What is wrong with you? You're not pissed off by that dynamic. It is wrong, it is abusive, it is a kind of injustice.

Why is it that the examples of these artist-run spaces are of smaller spaces, in what way does this represent an alternative to a commercial gallery, or even a larger artist-run space?

Jeffrey: Initially when I started doing the bathroom I spoke with Meg Duguid, founder of The Clutch Gallery which she worked with for a period of time. Paul curated the show, but someone had to carry it around, so I offered to do so. I carried it everywhere; I even managed to get into the White House with it. I agree with her on one thing she shared: there's no difference in the amount of work that you do to prepare for an art space, whether it be in a tiny purse, a bathroom, or a room-sized gallery. Preparing for the space, gathering the artists, coming up with a theme, curating, the time and effort – you're still putting in all of that work. The only difference is that it's less risky. The stakes in the bathroom are way far down in comparison to, for example, Slow Gallery. There was an element of fun, and I had decided that to run this space, that was important. If this small space lost its fun, if it became tense, and difficult, then I'm not doing it. I think this is one important factor in all these small spaces Paul had mentioned. This is why we can do wild things within these small spaces, that we wouldn't imagine doing in a bigger space.

How have these small artist-run spaces impacted the art scene in Chicago?

Paul: If you talk to commercial galleries, they would claim not to pay attention to artist-run galleries like ours, but a lot of people have an increased attention towards their work when they present in artist-based galleries. There's a lot of great artists here in Chicago, and we have this attitude where we're not going to wait to be acknowledged, we're going to go with the resources that we have and create a space for the people we think deserve recognition.

Jeffrey: There's a lack of support for critics and folks that write about art in Chicago, so the way that you get to know about what's going on is through connecting to a group of people that go around and discover until you find the spaces that you like. And I agree with Paul, there are really smart students here and they're all making fantastic work. They're not going to sit around and wait. They open up their apartments as spaces, and showcase their work no matter how small or strange the space.

AS Paul and Jeffrey continue to exhibit artwork in their unconventional spaces, as well as support other similar galleries, it is clear that artists have taken matters into their own hands.

Far from the constructed white gallery walls, these contemporary spaces help reimagine the context in which artwork is displayed, while also offering a friendly space for visitors to wander, interact, and in the case of Slow Gallery and The Loo, enjoy some homemade beer and a very well-decorated bathroom.

PAUL HOPKIN

IN 2009 Paul purchased a building in Pilsen with the intent of making
it his home and founding a gallery. Since then he has curated over 50
exhibitions as slow. He has also curated exhibitions for Heaven Gallery,
the Averill and Bernard Leviton A & D Gallery, Daly 208 Projects, and
Clutch Gallery. He has written catalog essays for exhibitions at the Chi-
cago Artists Coalition and the Robert V. Fullerton Museum, and articles
published in Newcity. He was a preparator for the De Jong Gallery at
the Harris Fine Arts Center, Brigham Young University and oversaw the
installation of many end-of-the-year exhibitions of freshman artwork at
the School of The Art Institute of Chicago. He received his MFA from
the School of the Art Institute of Chicago and his BFA from Brigham
Young University. He attended the Skowhegan School of Painting and
Sculpture. He is also an artist and educator. He was trained as a ceram-
ics sculptor, but his artwork also includes watercolor and ephemeral
sculptural materials like bread, margarine, and sugar.

JEFFREY GRAUEL

JEFFREY Grauel grew up in Southern California. He moved to Chicago to
attend the School of the Art Institute of Chicago. He became Slow's co
director in 2011 but has been involved since the project's beginning. He
has curated 3 exhibitions for Slow; FREE LOVE, ROBBERY IN PROGRESS,
and GILDED PROSCENIUM. He is the director and principal curator for
Loo. He has an MFA from the School of the Art Institute of Chicago and
a BA from California State University, San Bernardino. His professional
experience includes serving as Student Coordinator of Corporate Exhi-
bitions at the School of the Art Institute of Chicago, Exhibition Coordi-
nator at the Betty Rymer Gallery, Preparator at the Robert V. Fullerton
Museum, and Lead Preparator at the Wignall Museum/Gallery. As an
artist, his artwork has been exhibited locally, nationally, and in his ear.

ENGAGEMENT

LIFT TO RELEASE
Juan Camilo Guzmán

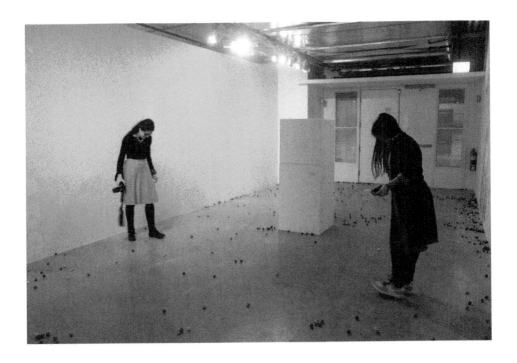

MY work in the show "Painting in Time Part 2" at the Sullivan Galleries is a minimalistic white cube filled with thousands of colored bouncing balls which are then to be released at some point by members of the crew during the performance. After this first "explosion of color", the balls spread freely through the gallery and the visitors were welcome to kick them, throw them against the walls, play with them or take them home. Here, the colored balls do not belong to the traditional white space, they are thousands, they are cheap, colorful, kitsch, they move freely, jump walls, can't be contained or sold. They are literally SMALL in size, while the "white cube" is large, as the official discourse says.

My work uses a "playful" attitude and popular culture language to touch on things like politics, power dynamics and neocolonialism, but also uses traditional art language and materials to talk about art, taste and aesthetics.

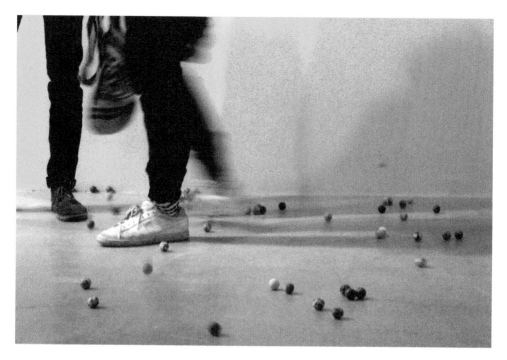

The installation is all white. The institutional frame is what determines the project. A context like this has a clear tendency to the "white", where white is not a color but a "totalitarian imaginary", and "art" is something that serves to "wash" the image. I think that every art is a scheme of the dominant whiteness, the very notion of "Art" is Eurocentric, it is the aesthetic representation of the dominant groups.

To participate in a "high cultural" exchange is a ritual that has been mechanized in our societies as a path of segregation. I am "invading" the gallery with something fun, not related with values as intellectuality and beauty, and that everybody loves from their childhood. The participation of people inside and outside the art world, is generated through a playful environment which is also one of the primordial ways of community building.

As a Latin American artist, everything I do is validated within a larger system of production that I am part of. The circumstance I am setting up facilitates a discussion about "othering" by telling immigrant stories, through ideas such as displacement, moving, forms of being categorized and even disappearance. I see this white context of the white gallery as a perfect place for that.

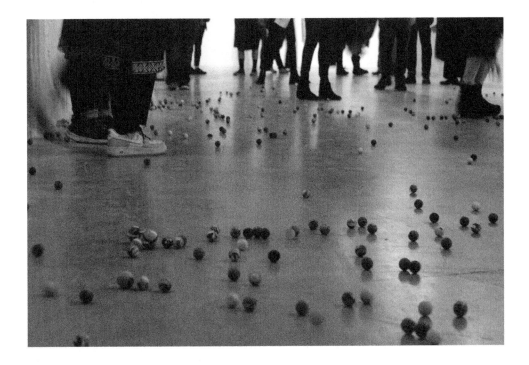

EXPANDING CARE
CURATION IN THE AGE OF ENGAGEMENT
Aletheia Wittman

WHEN I entered graduate Museum Studies, my expectation was to become a curator. As a newcomer to the field, it struck me as counterintuitive how much authority was held by an institutional agent with a title appearing so modest on paper. There is nothing in the Latin etymology of the word curator, "care taker," that prescribes inherent authority. The phrase evokes domestic tasks and invites application to any number of everyday activities, an interpretation no doubt informed by my own gendered and classed experiences. The more I have focused my practice and research in the realm of Curation, the more I understand the role of power in defining how-to-care in museums. Care has been used to frame the act of maintaining institutions and their self-interest, consolidating power in dominant cultures and narratives. On the other hand, when museums upend dominant practices and their associated power structures care can be understood as affirming the self-determination of communities. This realization completely challenged my understanding of how curation operates in museums and continues to inform my work as a curator. Building an analysis of the ways in which how-to-care and what constitutes care underpin museum practice has shaped how I enact care as a cisgender, white, able-bodied woman working in and with cultural institutions. In order to collectively advocate for the curation we desire to model in museums, I believe the field can benefit from exploring what has and what should constitute care.

Care, as a concept, and curation, as its application in museums, has been constructed through changing museological discourses of how museums should relate to people. For this reason, it is important to look at the history of the Curator's relationship with museum "Engagement" work. Engagement is a term commonly used in museums and cultural institutions to describe any labor related to building relation-

ships between institutions and people. The changing relationship of curation to the labor of engagement in museums can be charted through three distinct progressions of *whom or what* has been the subject of care in museums: object care, educative care, and liberatory care. I will use these progressions to frame my review of emerging discourses that inform how care is understood in a museum context. I will also draw from my graduate thesis research, in particular an analysis of the interviews I conducted with four museum curators that saw social justice and community engagement as integral to their practice. My findings, based on these interviews with curators, illustrate more liberatory modes of care and describe a curation less associated with authoritative positioning and more expansive in the scope of its relationship to the work of engagement.

FROM OBJECT CARE TO EDUCATIVE CARE

IN early European and US museums, ideas of curation and associated practices of care were referencing collections and the objects that comprised them.[1] As Hilde Hein points out, objects are *inherently* about people and ideas and that is where their value comes from.[2] However, the act of caring, even in early "public" museums, was oriented, not toward the well-being of people, but toward the object's role in the curator's and the curating institution's scholarship. One example being the "pillage and abductions of objects from sacred sites and cultural sanctuaries" that many museum collections are built upon.[3] The amassing and making accessible of collections without the consent of their owners is an act that shows no care for those people and their descendants.

While the stewardship of collections for scholarly purposes continued to play a defining role in museums of the 19th and early 20th century, museums also understood themselves to be the means by which the public could improve themselves and, by extension, a democratic society. "The public" was conceived to be at a deficit, a condition museums

1. Hilde S. Hein, "The Authority of Objects: From Regime Change to Paradigm Shift," *Curator: The Museum Journal*, no. 50 (2007).
2. Ibid., 79.
3. Ibid., 83.

could remedy through education. In this era, care was not only object focused, but also paternalistic.[4] Educational practices reinscribed the dominance of European knowledge and value systems, nationalism, and colonialism.[5] Thus, while museums generally understood their purpose was to serve the public through education, the freedom to learn, experience, and feel safe in museums continued to be extremely limited. The resistance of Curators to these early stages of museum and curatorial practice development is well documented.[6] Due to their reputation as bastions of elitism, museums with growing interest in engagement practices created and hired entirely new positions.[7] Curators were slow to adapt to the new ways in which the museum was preparing to engage with the public.

LIBERATORY CARE

FROM the mid 20th century up to our present moment, ideas of how-to-care have continued to expand in relation to museums. The third phase in the expansion of care in museums is centered around a discourse of liberation. Odalice Priosti writes, "According to our view, a museology of liberation would be the process by which communities… can build a memory as a resistance, a memory that does not subjugate to a model that was imposed, but with which it negotiates, imitating it and differentiating itself in multiple ways." Priosti's vision for museology is informed by Paulo Friere's pedagogy of liberation.[8] Within Priosti's "Museology of Liberation," the goal is to make space for the self-determination and knowledge of communities as a means of resistance against dominant structures. In relation to curation and curators, Christina Kreps states "Because of the hegemony of Western museology, most people have difficulty thinking and talking about museums, curation and heritage

4. Sharon Zukin, *Naked City: The Death and Life of Authentic Urban Places* (New York: Oxford University Press, 2010), 129.
5. Jennifer Barrett, *Museums and the Public Sphere* (Chichester, UK: Wiley-Blackwell, 2011), 53.
6. Ibid., 143.
7. Ibid., 147-148.
8. Odalice Priosti, "Memory, Community and Heritage Practice: Museology of Liberation and Resistance Strategies," 296.

preservation in terms other than those provided by Western museo-logical discourse."[9] Kreps sees her work as liberating museological discourse and curation from the limitations of European ideologies, and exploring alternatives that represent multiple voices and perspectives.[10] Within the context of Kreps' observations about curation, care enacted by museums should bring silenced or marginalized knowledge systems and voices to the center of museum practice, in particular Indigenous and local knowledge. Kreps and Priosti present a vision for museums wherein care is necessary for liberation and dismantling dominant mu-seum practices and ideologies.

EMERGING MUSEUM DISCOURSES OF CARE

IN addition to scholarly perspectives, emerging discourses around work museums can and should do tell us more about the ways how-to-care, or what constitutes care, is coming to be understood by museum pro-fessionals. For example, those discourses of:

Ally/Accomplice: Modes of engaging in liberation movements for those with power and privilege.

nikhil trivedi was the first to address the role of individuals that shape museums in the work of dismantling oppressions as they mani-fest both inside and outside the museum context.[11] Diana Falchuck has also notably written about the possibility of museums doing the work of allyship, using the *Race: Are We So Different?* exhibit as a case study.[12] Conversations around allyship and accompliceship have notably in-formed the development of two recent museum focused projects, the Museums & Race Initiative as well as MASS Action (Museum as a Site for

9. Christina Kreps, *Liberating Culture: Cross-Cultural Perspectives on Museums, Curation and Heritage Preservation* (London/New York: Routledge, 2003), 7.
10. Ibid., 8.
11. nikhil trivedi, "Oppression: A Museum Primer," *The Incluseum Blog*, February 4, 2015, https://incluseum.com/2015/02/04/oppression-a-museum-primer/
12. Diana Falchuck, "Can Exhibits Be Allies? Part 1 and 2," *The Incluseum Blog*, November 5 & 8, 2012, https://incluseum.com/2012/11/05/can-exhibits-be-allies-part-i/

Social Action)[13] It has been integral to the ongoing work of each project that organizers recognize and navigate their broad range of identities, related systems of oppression and the ways that these inform their organizing roles. Individual roles need this consistent examination and development as demonstrated by the fact that the idea of "accomplice" has been proposed as a mode that improves on that of "ally." A distinguishing aspect of being an accomplice includes a focus on relationships of and systems of accountability with Black, Brown, LGBTQI +, Indigenous, disabled, immigrant, women organizers and leaders.[14]

Community Membership: Responsibility to the greater fabric or whole you exist within.

This phrase and framework for best practices in community engagement is premised in an idea of a museum as accountable to the communities with which it engages. I want to acknowledge the advocacy of Stephanie Cunningham and her comments made at Carnegie Museum of Pittsburgh for "A Conversation about Inclusion" in October 2016. She specifically used "community member" to describe how museums should understand their role in relationship to communities. The phrase frames a museum as one member of many community members, as opposed to the focal point or the one member that dictates the terms of engagement. Porchia Moore writes extensively on museum relationships with communities and the way museum assumptions about communities and respectability politics are ways that museums prioritize themselves over communities.[15] The Community Member model is vital as it asks of museums to commit to the collective well-being of those with whom it wishes to share a community connection.

13. "Statement of Purpose," Museums & Race Steering Committee, https://museumsandrace.org/statement-of-purpose/; Porchia Moore, Aletheia Wittman, Elisabeth Callihan, nikhil trivedi, Janeen Bryant, and Sage Morgan-Hubbard, "Crafting courageous truths: The creation and philosophy of MASS Action: Museum As Site for Social Action," Center for the Future of Museums Blog, November 15, 2016, http://futureofmuseums.blogspot.com/2016/11/crafting-courageous-truths-creation-and.html

14. Jonathan Osler, "Opportunities for White People in the Fight for Racial Justice," https://www.whiteaccomplices.org/.

15. Porchia Moore, "R-E-S-P-E-C-T, Church Ladies, Magical Negroes, and Model Minorities," The Incluseum Blog, October 15, 2015, https://incluseum.com/2015/10/15/respect-church-ladies-magical-negroes-model-minorities-inclusion-community-to-communities/.

Empathy: Understanding experiences of another based on shared humanity.

The work of Gretchen Jennings, for example the Empathetic Museum Maturity Model, as well as Mike Murawski's writing and public speaking have played a large role in advocating the application of this concept in museums.[16] The premise of empathy is that museums, as public facing and engaging institutions, are responsible to bridge audiences through practice that critique instances of individual or group apathy. In this way, empathy poses a discourse of resistance to the ways separation can be a tool of domination by oppressive systems.

Intersectionality: The ways in which overlapping identities relate to systems of oppression.

Porchia Moore's scholarship has influenced the application of this term, originally coined in the field of Critical Race Theory by Kimberlé Crenshaw, to the museum field.[17] For example, through her leadership intersectionality became foundational to the work of the Museums & Race Initiative. To highlight the role and necessity of intersectionality in the practice of contemporary creatives, the Smithsonian Asian Pacific American Center hosted the watershed exhibition and event "Crosslines: A Culture Lab on Intersectionality" in 2016. These projects reject binary narratives of difference and have built an awareness in the field for the connections between liberation struggles.

Listening: Acknowledging self-deficit through showing up as a learner, not expert.

16. Gretchen Jennings, "An Update on the Empathetic Museum," *Museum Commons*, November 14, 2016, http://www.museumcommons.com/2016/11/update-empathetic-museum.html; Mike Murawski, "The Urgency of Empathy and Social Impact in Museums," *Art Museum Teaching*, July 11, 2016, https://artmuseumteaching.com/2016/07/11/the-urgency-of-empathy-social-impact-in-museums/.
17. Porchia Moore, "The Why of D+I: An [Afro]Futuristic Gaze at Race And Museums," March 7, 2016, *The Incluseum Blog*, https://incluseum.com/2016/03/07/afrofuturistic-gaze-race-museums/.

This framework for museum behavior was something I first experienced in readings about Asset-Based Community Development, which is premised on the idea that the starting point of any sustainable community development must be the assets of the community itself. This requires any person engaged in community development to first know the value of a given community's assets through learning and listening. For museums, this framework is broadly applicable. For example, the idea of listening is key in the concept of Open Authority, developed by Lori Byrd Phillips, which illustrates the way museums can be content facilitators and bring user-generated content to the center of their interpretation.[18]

Self-care: Affirming and making space for acts of self preservation.

bell hooks wrote that knowledge of the self, the self in relation to others and the time to build a "critical consciousness," all play a role in facilitating liberation.[19] Audre Lorde notably asserted that, "Caring for myself is not self-indulgence, it is self-preservation, and that is an act of political warfare." Lorde also wrote extensively about affirming anger felt in response to oppression and erasure and the use of this anger in defining a vision for liberation.[20] These ideas are only two examples from the rich discourse of self-care developed by radical, Black feminists. Museums have the power to change their workplaces through self reflection and interrupt the ways in which the well-being and self-care of employees is made to be a struggle. To demonstrate the integral nature of self-care, the MASS Action project intentionally incorporates the ethic of self-care into its institutional transformation toolkit. Likewise, museum projects, such as the previously mentioned Crosslines exhibit, bring previously omitted narratives of marginalized groups or individuals to the core, with the leadership of represented communities. These projects can be a means to preserve cultural heritage and themselves become sites of resistance and self-care.

While these examples are by no means comprehensive, it is meant

18. Laurie Byrd Phillips, *Defining Open Authority Tumblr,* accessed November 15, 2016. http://hstryqt.tumblr.com/.
19. bell hooks, "On Self Recovery," in *Talking Back: Thinking Feminist, Thinking Black,* (Boston: South End Press, 1988), 33.
20. Audre Lorde, *The Uses of Anger: Women Responding to Racism,* 1984, 131.

to demonstrate that collectively these frameworks represent some of the emerging vocabularies influencing how care is understood in museums today. Together, these ideas of care express a common interpersonal and experiential focus and a strong interest in deepening museum accountability to individuals and communities experiencing oppressions. If individuals with the least protections under society's laws and policies are not foremost in mind when we define how-to-care, then we have not truly designed engagement practice to address a comprehensive public. The discourses also represent a transposition of what is commonly understood as human scale behavior, demonstrating care for another person through the ways that we engage with them, to institutional scale behavior. This demonstrates a growing expectation that museums, as human-centered and operated institutions, should be accountable to the same standards of care that individuals aspire to enact in their daily lives.

TOWARD LIBERATORY CARE IN PRACTICE

AN expanding sense of what constitutes care in museums was also demonstrated during interviews I undertook for my Master's Thesis in Fall 2012. I interviewed four art museum curators working in museums publicly committed to social justice and community engagement. I interviewed curators at The Oakland Museum of California, The Bronx Museum of the Arts, The Guggenheim Lab in New York City, and the Yerba Buena Center for the Arts. The interviews allowed me to identify and compare emerging curatorial practices; "emerging" was used to refer to practices the interviewed curators understood as integral to their practice, but were unlike traditional, or object-focused, curatorial practices. While interviewees did not describe their practices in terms of "liberatory care," many of the practices they described are premised on the idea that curatorial care should be focused beyond object and educative care, and primarily responsive to the self-determined goals of local communities. In that sense, I understand many of their practices to be aspiring toward the realm of liberatory care.

Emerging practices that were most often identified by interviewees included:

» Planning exhibits and/or programs that address grassroots organizing or social justice movements;

» Responding to grassroots organizing and social justice movements as they happen;

» Exhibiting artists whose work comments on issues that relate to lived experiences of local communities;

» Connecting programming and exhibits to ideas of Place (shared meanings connected to a location, which imbue a space with value for one or more communities);

» Using culturally familiar gathering and participation formats to promote comfort;

» Inviting communities to share their creativity and their experiences;

» Collaboration with trusted community leaders on programs;

» Providing communities with direct access and representation in art exhibition and program development.[21]

Because each of the curators worked within institutions that publicly aligned themselves with social justice and/or community engagement practice, it is worth noting that these curatorial practices represented a small subset of arts institutions. Nonetheless, they indicate the expanded understanding of care that can take place both in the self-definition of curatorial positions and in the way curating functions in museums. These ways of working exemplify that the lines between "engagement" functions and traditional curatorial functions easily blur without dissonance in the practice of curators today.

21. Aletheia Wittman, "The Public Work of Care: Emerging Art Curatorial Community Engagement Practices" (Master's Thesis, University of Washington, 2012).

How should these findings, in the context of new ideas of liberatory care and emerging discourses of articulating care through museum practice, inform our actions and thinking in the field? For one, we should be wary of any impulse to maintain curation as a static concept or role; a rigid view of curation only benefits those people and ideas that already dominate the field. Room to redefine the practice of curation itself and invite it to be different based on context and community responsiveness, increasingly directs care and benefits toward people. As ideologies of how-to-care expand through efforts to demonstrate care as a tool of liberation, so do the possibilities and opportunities for curation in the age of engagement.

BIBLIOGRAPHY

Barrett, Jennifer. *Museums and the Public Sphere*. Chichester, UK: Wiley-Blackwell, 2011.

Bryant, J., Callihan, E., Moore, P., Morgan-Hubbard, S., trivedi, n. and Wittman, A. "Crafting courageous truths: The creation and philosophy of MASS Action: Museum As Site for Social Action." *Center for the Future of Museums Blog*. Accessed April 5, 2017. http://futureofmuseums.blogspot.com/2016/11/crafting-coura geous-truths-creation-and.html

Falchuk, Diana. "Can Exhibits be Allies? Part 1 & 2." *The Incluseum Blog*. Accessed November 15, 2016. https://incluseum.com/2012/11/05/can-exhibits-be-allies-part-i/

Hein, Hilde. "The Authority of Objects: From Regime Change to Paradigm Shift." *Curator: the Museum Journal*, no. 50 (2007).

hooks, bell. "On self-recovery." In *Talking Back: Thinking Feminist, Thinking Black*. Between the Lines, 1988.

Jennings, Gretchen. "An Update on the Empathetic Museum." *Museum Commons Blog*. Accessed November 15, 2016. http://www.museum-commons.com/2016/11/update-empathetic-museum.html

Kreps, Christina. *Liberating Culture: Cross-Cultural Perspectives on Museums, Curation and Heritage Preservation*. London/New York: Routledge, 2003.

Lorde, Audre. "The Uses of Anger." In *Sister Outsider*. Crossing Press, 1984.

Moore, Porchia. "R-E-S-P-E-C-T, Church Ladies, Magical Negroes, and Model Minorities: Understanding Inclusion from Community to Communities." *The Incluseum Blog*. Accessed April 5, 2017. https://incluseum.com/2015/10/15/respect-church-ladies-magical-negroes-model-minorities-inclusion-community-to-communities/

Moore, Porchia. "The Why of D + I: An Afrofuturistic Gaze at Race and Museums." *The Incluseum Blog*. Accessed November 15, 2016. https://incluseum.com/2016/03/07/afrofuturistic-gaze-race-museums/

Murawski, Mike. "The Urgency of Empathy and Social Impact in Museums." *Art Museum Teaching*. Accessed November 15, 2016. https://artmuseumteaching.com/2016/07/11/the-urgency-of-empathy-social-impact-in-museums/

Museums & Race Steering Committee. "Statement of Purpose." Accessed April 5, 2017. https://museumsandrace.org/statement-of-purpose/

Osler, Jonathan. "Opportunities for White People in the Fight for Racial Justice" http://www.racialjusticeallies.org/wp-content/uploads/2016/12/from-ally-to-accompliace.pdf

Phillips, Laurie Byrd. *Defining Open Authority Tumblr*. Accessed November 15, 2016. http://hstryqt.tumblr.com/

Priosti, Odalice. "Memory, Community and Heritage Practice: Museology of Liberation and Resistance Strategies." *EcoMuseums: Proceedings of the 1ˢᵗ International Conference on EcoMuseums*, Community Museums and Living Communities, Green Lines Institute for Sustainable Development, 2012.

Smithsonian Asian Pacific American Center. Crosslines: A Culture Lab On Intersectionality. Accessed November 15, 2016. http://smithsonia-napa.org/crosslines/

trivedi, nikhil. "Oppression: A Museum Primer." *The Incluseum Blog*. Accessed November 15, 2016. https://incluseum.com/2016/09/19/oppression-a-museum-primer-update/

Wittman, Aletheia. "The Public Work of Care: Emerging Art Curatorial Community Engagement Practices." Master's thesis, University of Washington, 2012.

Zukin, Sharon. *Naked City: The Death and Life of Authentic Urban Places*. New York: Oxford University Press, 2010.

PANOPTICAN'T
STRUCTURES OF POWER
Silvia Inés Gonzalez

SMALL and relatively short pages can contain powerful ideas that generate impact on socio-political systems currently at play. The zines include historical references of criminalization, architecture's physical imposition of power, questions for discussion/meditation, and prompts that invite people to consider the ways in which power dynamics affect our interactions to ourselves, each other and built environments. The zine is a record of a workshop hosted by the 96 Acres Project with Andrew and Angelo Santa-Lucia that is meant to be shared and used by readers.

Surveillance | Dehumanization

Surveillance is a post Enlightenment tool that serves as a form of policing and imprisonment.

Surveillance has historically most affected oppressed populations.

Justification for surveillance in jails:

- Visual evidence
- Maintain order
- Reduces assault
- Prevents drug smuggling
- Monitor officer behavior
- Enhanced search capability

The panopticon gave permanent visibility of inmates for automatic functioning of power.

Surveillance is built around the idea that you are always being watched and therefore you should police yourself.

We move in response to surveillance.

Surveillance

- How does surveillance affect our behaviors?
- What does surveillance look like today?

Radicalizing Space

Think back to a memory of a favorite places/spaces you have been to. Create a drawing of the interior and exterior of a radically humane space. What does it look like?

Panopticon

Jeremy Bentham, a philosopher, introduced the idea of the panopticon in the late 18th Century, which was an all "seeing" tower that implied inmates were always being watched.

"Morals reformed—health preserved—industry invigorated—instruction diffused—public burthens lightened—Economy seated, as it were, upon a rock—the gordian knot of the poor-law not cut, but untied—all by a simple idea in Architecture!"

We cannot define humane space based solely on what is already inhumane, broken and inefficient

1

2

As a conscious collective, we could define humane space through our perception and understanding of it

Criminal Theory

ENLIGHTENMENT

Criminal Theory—> Correction —> Body and Soul

The Enlightenment gave us:

- liberalism
- representative democracy
- religious freedoms
- rationality
- scientific method

Leads to the mechanization of punishment.

Special thanks to Panoptican't workshop facilitators:
Andrew Santa Lucia
Angelo Santa Lucia
List of Resources/Organizations:
96acres.org

PANOPTICANT

The Panoptican't
Power and Punishment

What is architecture's place between individual experiences of power and systemic interjections of it?

How have we historically conceptualized incarceration, power and place?

PRE- ENLIGHTENMENT

Crime —> Punishment—> Body

- Method of social control
- Public
- Morality based

What is the relationship between individual and systemic power?

Zine: SILVIA GONZALEZ

Reclaiming & Re-imagining Space

Interior

Exterior

Landscape

Colors

☐ ☐ ☐ ☐ ☐

Elements
1._____
2._____
3._____
4._____

Description: What elements are key in the space I am radically re-imagining? What is the purpose of this space? What does it look like? How does it feel to be in this space?

SMALL OBJECTS, BIG IMPACT
Laura Phillips

AANISCHAAUKAMIKW Cree Cultural Institute is located in Eeyou Istchee, a self-governing Cree region of the James Bay area of Northern Quebec, Canada. Upon entering our building you come into the Elders' Hall, where we usually have a "featured object" case.

In 2016 we used this case to curate a display of beaded barrettes which included loans from both Cree and non-Cree community members. Some of the lenders had many barrettes that they collected during their lifetimes. We mounted the barrettes on a commercially tanned moose hide using sticky-backed felt loops, and the hide was affixed to the backing board with sticky-backed Velcro.

Handmade barrettes are made using a variety of techniques: Appliqué beading, loom beading, and quillwork are some of the methods commonly used by Cree people as well as other Indigenous groups across North America. The designs range from symbolic, traditional geometric shapes and flowers to contemporary logos and cartoon characters. Girls and women of all ages wear these colorful accessories in their hair, adding a touch of culture to everyday outfits through the art of beadwork.

Our display featured about fifty barrettes, on loan from about twenty different people. This small display had a big visual impact and was a striking addition to the reception area where we welcome visitors to Aanischaaukamikw.

CAPTIONS FOR THE IMAGES ON THE FOLLOWING PAGES:

1. Beadwork barrette display at Aanischaaukamikw Cree Cultural Institute in Oujé-Bougoumou, Quebec, Canada. Layout curated by Caroline Mianscum. Photograph by Fiona Hernandez.
2. Aanischaaukamikw Cree Cultural Institute, Oujé-Bougoumou, Quebec, Canada. Designed by Douglas Cardinal in the style of a *saabtuan*. Photography by Laura Phillips.

MARGINALIZATION

THE ART MUSEUM CHASM
Marjorie Schwarzer

It is a problem when [those] ... at the commanding heights of the private economy appropriate more than their fair share of the nation's expanding economic pie.
— Economic Policy Institute, 2016.[1]

This essay is dedicated to The Organization United for Respect (OUR Walmart).

IN 1907, the former director of a training program for art and archaeology curators penned a letter to the editor of The Nation. Richard Norton was responding to a query about wealthy American collectors who continually build new museums without hiring professional staff to run them properly. Stating that he knew many talented students who would eagerly welcome opportunities to help these new museums, Norton pointed to the problem: money. "The governing boards of our museums have lots of it," he said, but they want to invest in things, not people. "The graduates of our schools can have but little hope of being valued at their true worth ... and when that day comes ... the public will find that museums accomplish something more than the mere storing of private collections."[2] One hundred and ten years later, Norton's words still resonate. Since 1907, museums have persevered in their quest to accomplish something more. Yet, today, museums of all disciplines and sizes are circling back to the days when they were beholden to the values of ultra-wealthy collectors. The lack that Norton identified has not diminished. In fact, it has grown, especially in marquee art museums.

1. Estelle Sommellier, et. al., "Income inequality in the U.S., by State, Metropolitan Area and County," *Economic Policy Institute* (2016):1, accessed December 20, 2016.
2. Richard Norton, "Training for Curators," *The Nation* (1907): 119.

In this essay, I dive into the chasm that exists between the collectors who control museums and the people who work in them. I begin by reviewing American museums' efforts during the twentieth century to advance from private repositories into civic-minded institutions. I then diagnose two twenty-first century economic trends that threaten to undermine this progress. In the spirit of *Fwd: Museums*, this essay raises more questions than it provides answers. But they are important questions with which our profession needs to grapple if we truly intend to move museums forward.

First, let's go back to 1907, the year Congress amended tariff laws, enabling tycoons like J. P. Morgan to import European art collections into the United States. American captains of industry like Morgan needed places to store and display their treasures: hence the founding of museums, often on public land. As the century unfolded, technological and communication innovations; public education; urban infrastructure improvements; civil rights movements and other social and economic advances in America helped to democratize the museum, bringing more voices into the galleries and corridors of decision-making.

Politicians saw the potential of museums to serve as platforms for civic pride. Federal programs including the Works Progress Administration (1930s), the National Endowments for the Arts and Humanities (1960s) and the Arts and Artifacts Indemnity Act (1970s) provided money for progressive programs and exhibitions. Tax reform established incentives for collectors of all stripes to donate works to museums. By the late 1970s, art museums were no longer solely the purview of an elite class of collectors. Professional associations and government agencies gave voice to educators, artists, curators, scholars and community organizers who joined a growing museum field and pushed the museum profession to articulate public service as its core value. During the Reagan years, two formidable waves with the potential to erode this progress began to form: economic inequality and changes in the art market. The museum field, so committed to its public face and progressive ideals, was willing to ignore these trends, or at least ride them out, rather than confront them.

In 2006, the American Association (now Alliance) of Museums published my book, *Riches, Rivals and Radicals: 100 Years of Museums*

of America (RRR). My goal was to trace museums' development over the twentieth century. Researching and writing *RRR* led me to theorize that American museums, looked at together, could be seen as prisms of American democracy, reflecting our struggles and triumphs as a people and a nation.[3] Compare entering a museum in 1907 with the experience of visiting one now. There was no doubt that museums had evolved into "something more."

In 2008-09, the Great Recession hit. The waves of income inequality and art collecting came crashing down on museums. Income distribution in our nation became dangerously lopsided. As beneficiaries of that wealth, mega-wealthy art collectors began to re-exert their command over public institutions.

THE RETURN OF INCOME INEQUALITY

IN the late 1970s, after years of shrinking, the income gap began to grow. Economic journalist Thomas Byrne Edsall coined this phenomenon as "the return of inequality."[4] The rich became even richer during the post-Great Recession recovery. As of 2013, the annual income of the top one percent of Americans was roughly twenty-five times higher than that of the bottom 99 percent. This means that for every dollar someone in the thin top strata earned that year, the rest of us made four cents. According to data from both the IRS and Federal Reserve, a mere 160,000 families control twenty percent of the nation's wealth.[5]

Despite their rhetoric of serving the public good, most art museums' payrolls mirror this pattern. Charity Navigator tracks the finances of over 4,000 nonprofit organizations (excluding private colleges and universities). Because it uses IRS-990 data, its figures are more reliable than museums' self-reported responses to internal industry surveys. Analysts found that the median annual salary of CEOs of arts and cultural nonprofits in 2014 was $150,000, while CEOs of large nonprofits

3. Marjorie Schwarzer, *Riches, Rivals and Radicals: 100 Years of Museums in America* (Washington DC: AAM Press, 2006): 1.
4. Thomas Byrnes Edsall, "The Return of Inequality," in *The Atlantic Monthly*, 1988.
5. Emmanuel Saez and Gabriel Zucman, "Wealth Inequality in the United States since 1913: Evidence from Capitalized Income Tax Data," in *The Quarterly Journal of Economics*, 2016.

of all types earn a median of $256,000.[6] These ranges indicate that, by and large, nonprofit executives earn modest salaries in relation to their considerable workloads.

This is not the case in art museums. Digging into the 2014 tax forms of twenty-five top-tier art museums across the United States, I calculated the median salary of their directors: $650,000. This puts art museum directors in the very top tier of all nonprofit executives. MoMA reported the highest museum CEO annual salary and benefits package: $2.1 million.

I cross-compared CEO salaries with those reported at the same institution for entry-level professional staff on the crowd-sourced website Glassdoor.com. The average starting salary for an assistant curator—$50,000—amounts to about seven cents to every dollar earned by the same museum's CEO. In high cost of living areas like New York City, that figure goes down to about five cents. Why do governing boards of art museums approve such out-of-kilter salaries for chief executives while not addressing the low salaries of other staff? The answer is complex, but I believe it relates to the second wave: the celebrity and hype associated with what art critic Ben Lewis has called "The Great Contemporary Art Bubble."[7]

THE RETURN OF ART INSANITY

THE Great Recession saw a boom in biennials and art fairs. They put the art market into overdrive, catering to status-seeking billionaires and A-list artists. When interest rates are low and the stock market uncertain, the ultra-wealthy park their excess assets into what the IRS calls "treasure assets," luxury items like gemstones, antiques and artwork. Since 2007, the wealthy have purchased more art than ever.[8] During the Great Recession, as endowments deflated and museums laid off staff, art sales shattered records. Prices rose. Contemporary art museums

6. "Charity Navigator 2016 CEO Compensation Study," (charitynavigator.org, 2016.
7. Lani Asher, May 19, 2010, The Great Contemporary Art Bubble, *Future Perfect*, 1/15, http://www.artpractical.com/feature/the_great_contemporary_art_bubble/
8. Katherine Tyrell, June 16, 2012 (4:51 p.m.), "Why do wealthy people invest in art?," *Making A Mark* blog, http://makingamark.blogspot.com/2012/06/why-do-wealthy-people-invest-in-art.html.

were priced out of the market. The question then became: how could privately-held art find its way into the public museum?

In 2006, after years of chipping away at incentives for collectors to donate art to museums, Congress eliminated "the fractional art gift," one of the last remaining tax loopholes that helped art museums curry favor with collectors.[9] Absent favorable tax deduction mechanisms, the new class of collector eschewed public institutions. Rather than collaborate with existing museums, with their pre-existing missions and bureaucratic staff structures, some prominent collectors elected to go it alone. Witness legendary homebuilder Eli Broad, hedge fund billionaire Mitchell Rales and Walmart heiress Alice Walton. All sit on the boards of major museums. Yet to show off their personal art collections, each built a "vanity" museum: Broad's eponymous The Broad in downtown Los Angeles (2015), Rales' Glenstone in suburban Washington, DC (2006), and Crystal Bridges in Bentonville, Arkansas (2011). To each founder's credit, all three museums employ professional staff, admit visitors free-of-charge and offer educational programs. The art is well-cared for and beautifully displayed. Yet who is setting the agenda? Do professional staff working in vanity museums have license to advance the field's progressive values? Or are they beholden to their founders' personal narratives?

FALLING INTO THE GAP

WHAT if a city rebuffs a mega-collector's desires to build a vanity museum? This happened in San Francisco, adding a twist to the intersection between private wealth and art collecting. In May 2016, the San Francisco Museum of Modern Art (SFMOMA) tripled its gallery space with a successful downtown expansion; the top three floors are now known as the Fisher Galleries. The cloud hanging over the project is a strings-attached agreement that is reshaping SFMOMA's curatorial program and policies. In 2009, the City rebuffed The Gap founders Doris and Donald Fishers' plans to build a private museum on public land for their collec-

9. Donn Zaretsky, September 6, 2006 (9:53 p.m.), "The End of Fractional Gifts?," *The Art Law Blog*, http://theartlawblog.blogspot.com/2006/09/end-of-fractional-gifts.html.

tion of modern art.[10] To keep this extraordinary collection from leaving San Francisco or going to auction, SFMOMA came to the rescue. Here's the catch: the family's foundation added 1,100 artworks to SFMOMA's collection, but they did not relinquish ownership of the art. The complicated loan arrangement stipulates that for the next 100 years, sixty percent of art on display in SFMOMA's formal indoor galleries must, at all times, come from the Fisher hoard: a collection largely consisting of work by A-list white male artists.[11] "Welcome to winner-take-all art history," wrote critic Jason Farago, after he viewed the opening installation.[12] The Fisher loan agreement is difficult to parse. As SFMOMA explained it to me in a personal correspondence, 35 percent of the museum's current art display spaces must be at least 75 percent Fisher. If the museum expands again, the Fisher allocation percentage will go down. But this doesn't change another stipulation of the loan agreement; every ten years, the museum must mount a year-long 100% Fisher exhibition in the Fisher Galleries. Should mega-collectors' private tastes dominate the curatorial program at public museums? More pointedly, can the museum workforce and those who aspire to careers in the field go beyond serving as apologists for the rich?

GOING FORWARD

"ART," curator and art historian Kellie Jones reminds us, "allows us to dream, to think, to imagine something different," to visualize a way to change the world.[13] The museum workforce increasingly echoes this humanistic vision of changing the world. The theme of 2017's AAM conference—Gateways for Understanding: Diversity, Equity, Accessibility, and Inclusion in Museums—is evidence of our field's progressive ethos and aspirations toward using museums to advance social justice values.

10. John King, "Fishers give up on plan for Presidio art museum," *San Francisco Chronicle*, July 2, 2009, Accessed 2016.

11. Charles Desmarais, "Unraveling SFMOMA's Deal for the Fisher Collection," *San Francisco Chronicle*, August 20, 2016.

12. Jason Farago, "It's Art History on Steroids, but Must go beyond Big Names," *The Guardian*, April 29, 2016.

13. Dana Evans, "How to work in the art world without selling out your politics," *New York Magazine*, October 24, 2016.

Long is the list of urgent social and environmental issues discussed in museum conferences and publications, among them: decolonizing the museum, diversifying the workforce, fighting for pay equity. But are dreams and talk enough to move us forward?

The Organization United for Respect (OUR Walmart) advocates for the rights of Walmart retail workers. In 2015, its union organizers visited the company's headquarters in Bentonville, Arkansas. Their goal was to press for living wages. While there, they visited Crystal Bridges and, like many museum visitors, they recorded their visit on their phones.

"So how do you feel being here?" asks one organizer to a longtime Walmart worker named Zahia as they stroll through Crystal Bridges' gardens. Zahia doesn't know that Crystal Bridges paid its founding director a salary of over $700,000. She also doesn't know that the museum's security guards' hourly wage is fifty percent higher than her own wages. Nonetheless her gut tells her something is very wrong. "I have mixed feelings," she begins in a measured tone. "I mean the potential for it [the museum] to be great is there, but I think they did the wrong thing." Her voice breaks. "All our hard work and the wages that we don't earn goes to this building filled with these nice things that are only for a few people to see. If they did the right thing it would have incredible potential to impact everybody." Zahia continues, fighting tears: "This art is nice. But it only reflects a small part of what we as Americans stand for and who we are. We are something so much more than this."[14]

Museum workers need to ask why our field's economic equation leans more to "nice things" than to people. How can museums justify the costs of building and maintaining pristine environments for art purchased by billionaires over paying fair wages to their own workforce? Why does our society, and particularly the elite portions of it, prioritize things and status over the social good? Are museum workers complicit in letting the system get away with this disparity of values?

Museum workers have always struggled to balance our institutions' economic underpinning with our professed humanistic values. We have much to learn from union organizers, economists, attorneys and others who stand up to large systems, expose their biases and fight for change.

14. Andrea Dehlendorf, co-director, Organization United for Respect, personal interview with author, 15 November 2016.

The ride across the current waves will be rough. But the quest is worthy. When we look back on history, how do we want America's museums to reflect our nation back to us: as a prism or as a chasm? And who do we want to answer that question: the top point-one percent—or the rest of us?

BIBLIOGRAPHY

Asher, Lani, May 19, 2010, The Great Contemporary Art Bubble, *Future Perfect*, 1/15. Accessed 2017: http://www.artpractical.com/feature/the_great_contemporary_art_bubble/

Desmarais, Charles. "Unraveling SFMOMA's Deal for the Fisher Collection." *San Francisco Chronicle*, August 20, 2016. Accessed 2016. http://www.sfchronicle.com/art/article/Unraveling-SFMOMA-s-deal-for-the-Fisher-9175280.php.

Edsall, Thomas Byrnes. "The Return of Inequality." *The Atlantic Monthly* (1988). http://www.theatlantic.com/past/politics/ecbig/edsalleq.htm.

Evans, Dana. "How to work in the art world without selling out your politics." *New York Magazine*, October 24, 2016.

Farago, Jason. "It's Art History on Steroids, but Must go beyond Big Names." *The Guardian*, April 29, 2016. https://www.theguardian.com/artanddesign/2016/apr/29/sf-moma-review-warhol-fishers-collection-ellsworth-kelly.

King, John. "Fishers give up on plan for Presidio art museum." *San Francisco Chronicle*, July 2, 2009. http://www.sfgate.com/news/article/Fishers-give-up-on-plan-for-Presidio-art-museum-3225626.php.

Moore, Porchia A. Nov/Dec 2016. "The Inclusive Museum Movement: Creating a more inclusive, equitable and culturally responsible museum field," *Museum*, 18 - 19.

Norton, Richard. "Training for Curators." *The Nation*, 1907.

Saez, Emmanuel and Gabriel Zucman. "Wealth Inequality in the Unit-
ed States since 1913: Evidence from Capitalized Income Tax Data." *The Quarterly Journal of Economics*, May 2016. http://eml.berkeley.edu/~
saez/SaezZucman2016QJE.pdf.

Schwarzer, Marjorie. *Riches, Rivals and Radicals: 100 Years of Museums* in America Washington DC: AAM Press, 2006.

Sommellier, Estelle, et. al., "Income inequality in the U.S., by State,
Metropolitan Area and County," *Economic Policy Institute*, (2016).
Accessed December 20, 2016, http://www.epi.org/publication/in-
come-inequality-in-the-us/.

Weil, Stephen E. "From Being about Something to Being for Somebody:
The Ongoing Transformation of the American Museum." *Daedalus* (Summer 1999), 229–258.

CRITICAL NARRATIVES OF THE MARGINALIZED
Karen Vidángos

I am a Latina
Born of Bolivian immigrants

I am diversity
Admire Kusama, Kruger, and Kahlo

Am I part of the 3% yet?[1]

Museums
I am not a trend
I am not a trend
I am not a trend

First-generation perspectives
En español y inglés[2]

Museums
I am not a trend
I am not a trend
I am not a trend

I hear the voices echo
Centuries of drowning messages

1. Roger Schonfeld, Liam Sweeney, and Mariët Westermann, "The Andrew W Mellon Foundation: Art Museum Staff Demographic Survey" (Mariët, July 28, 2015). In an art museum staff survey, it was found that "White Hispanics" were severely underrepresented in various positions, including curatorial, conservator, educator and leadership, accounting for only 3% of the total.
2. Translation: *In Spanish and English*

Can you hear us?

Museums
We are not a trend
We are not a trend
We are not a trend

BIBLIOGRAPHY

Schonfeld, Roger, Liam Sweeney, and Mariët Westermann. "The Andrew W Mellon Foundation: Art Museum Staff Demographic Survey." The Andrew W Mellon Foundation, July 28, 2015. https://mellon.org/media/filer_public/ba/99/ba99e53a-48d5-4038-80e1-66f9ba1c020e/awmf_museum_diversity_report_aamd_7-28-15.pdf.

LA MADRE CHIQUITA
William Camargo

MY madre is chiquita in size, but enveloped in power and resilience. She constantly tells us her small size has not deterred her from the journey she has taken from Guerrero, Mexico to Anaheim, California. In the late 80s and early 90s, during a surge in ICE raids in Southern California, she used her small size to hide from ICE agents. She claims small has an advantage physically and mentally and we cannot look down when they want to belittle a whole immigrant community to one stereotype. She says, "vine para que ustedes sean grandes, y los grandes vienen de los pequeños."

THE WORLD IN A BOX
Tim Gorichanaz

I put the world into a box

A box an inch or two around.

Inside I put the people

And the rivers and the towns.

I look into this box

When I feel the need

To see the things I'd like to see

And the things that I've seen.

I set the box back on the shelf

Then I replace its lid.

And I can't help but wonder

What sort of box I'm in.

LOCATION

COMPRESSED, COMPACT, CONCISE, AND REFINED
A MUSEUM IN SWITZERLAND
Deniz Balık

CAN small museums convey as much body of knowledge as large museums? Even before that, does the museum still function as a conveyor of knowledge and provider of education? Is a small museum a slice or a section of a large museum? Or does it have the potential to form wide-ranging discourses per se? While large museums and institutions try to find new ways to attract wider audiences by introducing more impressive exhibitions or proposing new types of activities and performances, do small museums share similar concerns?

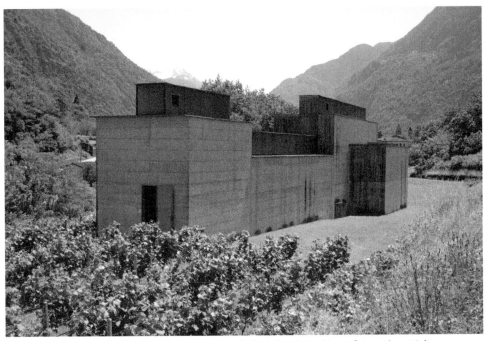

La Congiunta Museum in Giornico, Switzerland (archive of Jonathan Lin)

This paper focuses on a small museum, called La Congiunta, in Giornico, a city in the region of Ticino in southern Switzerland (Figure 1). It was designed by the Swiss architects Peter Märkli and Stefan Bellwalder, between 1989 and 1992, in a narrow valley of mountains, forests, and lakes, flanked on one side by a railway line and the Ticino River on the other. The building was designed as a "grey concrete box" with the specific intention to house thirty works by the Swiss sculptor Hans Josephsohn (1950-1991), whom Märkli is an admirer of.

This paper uses the museum as a tool to elaborate challenges and intentions of an unconventional small museum that turns its small scale into creative potential. Architectural literature discusses La Congiunta as a masterly accomplishment and an impressive building due to the geometrical proportions of basic volumes, use of raw materials, and architect's references to Greek or Roman architecture.[1] Instead, this paper argues that the significance of the museum derives from intuition, sensual interpretation, and intense encounter of artworks, architecture, and audience. The museum is not only small in size, compared to the traditional functions of an art museum; it is also compressed in artistic narration, compact in architectural composition, condensed in use of materials, and concise in conveying affects and sensations. This paper demonstrates that small museums, such as La Congiunta, emerge as a refined answer to the swiftly flowing trends of the image-driven culture in our fragmented world, by delivering succinct information and showing a limited number of collections in a short period of time.

COMPRESSED

THE museum experience of La Congiunta begins when visitors arrive at Giornico. They should, first of all, obtain the entrance key of the museum from a local café, since the architects intended to deliver an experience as personal as possible. Therefore, with the emphasis on aesthetic

1. For primary references with this perspective, see: Claudia Kugel, "Raw Intensity," *Architectural Review* 203/1212 (1998): 70-71; Mohsen Mostafavi, ed., *Approximations: The Architecture of Peter Märkli* (London: AA Publications, 2002); Pamela Self, "Material Presence and the Mystery of the Object," *Architectural Research Quarterly* 6/2 (2002): 190-192; Simon Unwin, "La Congiunta," in *Twenty-Five Buildings Every Architect Should Understand*, ed. Simon Unwin (London, New York: Routledge, 2015), 80-86.

experience, the display of artworks becomes a means to deliver affects, rather than an end. The contemporary idea of art museums suggests that exhibition spaces and artworks are intensely merged with the audience as critical participants, so that aesthetic experience forms a dialog between public narratives of museum and individual narratives of audience.[2] As the physical space is stratified and transformed into an experiential one, it recalls Heidegger's notion of *Dasein*, which literally means "being there" in German and refers to "being-in-the-world".[3] *Dasein* suggests the conception of human beings dwelling in relation to each other, since there is no consciousness as such, separated from an object in the context of the world. For Heidegger, the idea of perceiving architecture as a phenomenological object leads to the notion of experience – a network of spatio-temporal relations. The idea of "being" becomes primarily phenomenological, rather than cognitive, because people perceive the world as it appears to them. In the case of La Congiunta, spatial experience as a cognitive-perceptual process begins outside the museum, not in it.

After a short walk in the vineyards of Giornico one arrives at the museum, which, from a far, may be compared to a worn warehouse for grapes. The museum design figures as the articulation of rectangular volumes, perceived through a complicated part-whole relationship. There are no paths leading to the entrance, so that the visitor moves along the entire length of the façade in order to find the north entrance. A simple metal door, raised above the green ground with a small plate cantilevered out, marks the entrance (Figure 2). Opening the door, the visitor encounters a series of spaces displaying Josephsohn's artworks. Once inside, the visitor is completely separated from the outside environment. The museum offers a place for contemplation away from the rest of the world.

Unlike a traditional museum, which has additional services such as an entrance area, ticket purchase desk, library, café, shop, conference hall and so on, this small museum contains none of these; not even

2. Hilde Hein, "Museums: From Object to Experience," in *Aesthetics: The Big Questions*, ed. Carolyn Korsmeyer (Malden, MA: Blackwell Publishing, 1998), 106.

3. The German philosopher Martin Heidegger (1889-1976) presents his idea of *Dasein* in his seminal work, *Being and Time* (*Sein Und Zeit*), published in 1927. See: Martin Heidegger, *Being and Time*, trans. Joan Stambaugh (Albany: State University of New York, 1996).

restrooms. Märkli states that these services could be provided in other facilities in the city, yet their aim was to make people come to La Congiunta exclusively to see the artworks.[4] Being simply an art container, the museum consists of only gallery spaces, formed by walls, floors, and the ceiling. Likewise, in his exhibitions, Josephsohn uses simple presentations for his works, with no labels or indication of titles and dates; only figures are installed on a base or a wall.[5]

Museum entrance (archive of Trevor Patt)

Inside, artworks are installed chronologically, compressing the three phases of Josephsohn in three small galleries, narrated spatially. As one walks along the exhibition axis, the sense of movement dominates the changing volumes, spatializing the museum as a sequential

4. Giovanni Leoni, "Peter Märkli – La Congiunta," *AREA* 44 (1999): 51.
5. John-Paul Stonard, "Hans Josephsohn," *Artforum* (2008): 454.

space, a series of temporal events. The first space contains six low reliefs made in the 1950s and 60s, the second space holds high reliefs of the 1970s, and lastly the third space, which also has four niches with high reliefs, displays reliefs from the 1970s and figures from the 1990s.[6] These three spaces, which correspond to the beginner, advanced, and master levels of the sculptor, are connected to each other with openings raised above the ground. The thresholds make one aware of stepping from one frame into another.[7] As the first threshold separates the visitor from outer world, others metaphorically represent artistic thresholds of Josephsohn. Therefore, crossing one space from another becomes both a physical and a sensual performance.

COMPACT

THE integrity of the artist's workspace and the exhibition space can be perceived in Josephsohn's sculpture studio and the La Congiunta Museum. While Josephsohn was working in his naturally-lit studio, his sculptures were placed on top of one another, and side by side on the ground. Similarly, in La Congiunta, Josephsohn's sculptures were installed on concrete surfaces and lit only by natural light. All lighting is obtained through translucent skylights on the sheet metal roof. Märkli is aware of the primary importance of light on the display of sculptures, since the way a sculpture is lit affects the quality of its perception. The change of natural light in La Congiunta directly affects galleries, making the sun, fog, and clouds change the interior atmosphere by casting shadows or filtering sunbeams. Light thus becomes a phenomenological dimension, continuously changing the way artworks and spaces are perceived (Figure 3). It makes specific parts of the sculptures and galleries clear, while others remain in the darkness.

Most museum designers stabilize climate and moisture inside the gallery space to protect artworks from unwanted climatic conditions. Yet Märkli envisions architecture with the principle of 'constant evolu-

6. The first space is approximately 15 to 20 feet with a 25-foot high ceiling. The second is roughly 30 feet with a 15-foot high ceiling. The third has the same size as the first space. Joe Fyfe, "Hans Josephsohn's Lateness," *Art in America 1* (2008): 96-97.
7. Unwin, "La Congiunta," 82.

tion' allowing natural conditions such as weather to change the building. He does not only mean the outer surfaces of the building, since the interior has material corrosion on walls and floors as well. He states that he designed this space for sculptures, rather than people.[8] Thus, it is no surprise that this museum is not comfortable for people, for it has neither electricity nor climate control and insulation.[9] Furthermore, there are no openings in the walls; so walls are basically constructed as archetypal elements that separate and isolate. Following Märkli's intention, this museum, which looks compact, inaccessible, and rough from the outside, opens itself up to the ones who are ready to encounter and engage with the works of art integrated with architecture.

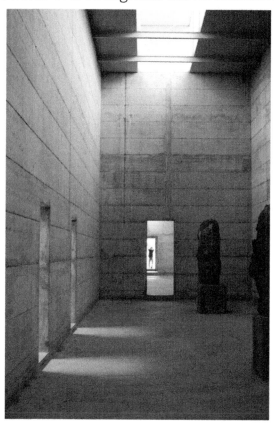

Sequential galleries in light and shade
(archive of Jonathan Lin)

8. Beatrice Galilee, "Peter Märkli," *Iconeye* 59 (2008), accessed December 1, 2016, http://www.iconeye.com/component/k2/item/3453-peter-märkli.
9. Kugel, "Raw Intensity," 71.

CONCISE

ART has the potential of producing complex sensations and inexhaust-ible levels of intense contrast. As the phenomenological approach suggests, juxtaposed layers produce contrasts in a system. They dialecti-cally render one another visible and ambiguous. In the case of La Congi-unta, the emphasis is on affect and emotional response evoked through materials, as both art and architecture are enriched by means of indi-vidual perceptions.[10] The museum and sculptures define and comple-ment each other, rather than dominating or being merely a decoration. Constructing a spatial narrative, the artistic encounter of architecture and artworks is enhanced through movements of visitors, placement of artworks, changing ratios of the gallery spaces, raw qualities of mate-rials, monochrome interior, and natural light. The narrative reaches a climax in the tension between Josephsohn's textured bronzes and La Congiunta's textured concrete casts.

When looked closely at the walls, traces of construction tools can be seen on the concrete surfaces. Similarly, material joints give the im-age of being layered.[11] Similarly, Josephsohn is interested in the appear-ance of body as a conveyor of experience.[12] His use of unmanipulated and unprocessed material through seemingly random accumulation makes sculptures look like conceptual sketches.[13] They appear as if they are never going to be completed; yet the sculptor does not intend to indicate a sense of completion after all.[14] One can see the layers and roughness made by Josephsohn's fingerprints, knife swipes, and gouges. In this sense, his sculptures bear contrasts, such as form/formlessness, completeness/ incompleteness, momentariness/continuity. The aes-thetic experience of contrasts, which transforms into one another and composes a dynamic network of relationships, reveals the potentials of space. One can sense the intentions of Märkli and Josephsohn by observing the material and immaterial layers of contrasts, since their manipulation of materials and spaces is a concise version of their works.

10. Self, "Material Presence and the Mystery of the Object," 192.
11. Unwin, "La Congiunta," 82.
12. Fyfe, "Hans Josephsohn's Lateness," 93.
13. Stonard, "Hans Josephsohn," 454.
14. Fyfe, "Hans Josephsohn's Lateness," 94.

REFINED

TODAY the strict borders of concepts become blurry and seem to pene-
trate each other. As Heidegger argues, *Dasein* refers to personal expe-
riences apart from the objective and scientific understanding of the
world and interpretation of life. He opposes the conception of space
merely as a mathematically measurable geometrical system of forms, di-
mensions, and proportions.[15] In parallel, constructed buildings, in Heide-
gger's terms, are perceived through tactility and experience, rather than
being conceived separately and objectively. With an emphasis given to
aesthetic experience, the narrative construct of a museum becomes
individual and divergent. The museum emerges as a continuously inter-
active and evolving system, making visitors encounter new meanings
and relationships.

The narration of La Congiunta is constructed by re-defining the
space of art display from a critical point of view. According to Märkli,
the museum is rough, difficult, cold, and inaccessible, with the qualities
of both a neglected ruin and a monument.[16] With its strong qualities,
the museum is detached from image-making, marketing strategy, con-
sumption system, and culture industry in the profit-oriented artistic and
architectural domain. The use of raw materials makes visitors experi-
ence matter directly.[17] In the phenomenological sense, the physicality of
materials makes one engage in the world, or brings back memories. The
private experience encourages visitors to interact with spaces and art-
works by touching, feeling, and contemplating, as soon as one shuts the
door behind an image-dominated world. Additionally, with its conven-
tional approach to architecture, the museum challenges contemporary
culture, which treats artworks as merchandise on a vitrine. Rather than
being a spectacle with an objective of commercial success, the muse-
um has a humble human-scale, which relates to individuals and their
personal experiences. Evaluated from a Heideggerian point of view, the

15. Branco Mitrović, *Philosophy for Architects* (New York: Princeton Architectural Press,
2011), 122, 131.
16. Galilee, "Peter Märkli."
17. Kugel, "Raw Intensity," 71; Self, "Material Presence and the Mystery of the Object," 190.

museum comes forth not by the geometrical composition of spaces, but by spatial experiences delivered through them. The museum is not a tourist destination or an urban landmark, such as the Louvre or a Guggenheim, but it is a designerly instrument of achieving a condensed architecture. After its twenty-five years of existence, La Congiunta still has a lot to teach through its refined architecture as a challenge to this image-oriented and fragmented world in-flux.

ACKNOWLEDGEMENTS

THE substance of this article derives from earlier drafts of my master's thesis at Istanbul Technical University. I would like to thank my M.Sc. supervisor Prof. Dr. Semra Aydınlı for introducing me to phenomenology.

BIBLIOGRAPHY

Fyfe, Joe. "Hans Josephsohn's Lateness." *Art in America* 1 (2008): 92-97.

Galilee, Beatrice. "Peter Märkli." *Iconeye* 59 (2008). Accessed December 1, 2016. http://www.iconeye.com/component/k2/item/3453-peter-märkli.

Heidegger, Martin. *Being and Time*. Translated by Joan Stambaugh. Albany: State University of New York, 1996.

Hein, Hilde. "Museums: From Object to Experience." In *Aesthetics: The Big Questions*, edited by Carolyn Korsmeyer, 103-115. Malden, MA: Blackwell Publishing, 1998.

Kugel, Claudia. "Raw Intensity." *Architectural Review* 203/1212 (1998): 70-71.

Leoni, Giovanni. "Peter Märkli – La Congiunta." *AREA* 44 (1999): 50-59.

Mitrović, Branco. *Philosophy for Architects*. New York: Princeton Architectural Press, 2011.

Mostafavi, Mohsen, ed. *Approximations: The Architecture of Peter Märkli*. London: AA Publications, 2002.

Self, Pamela. "Material Presence and the Mystery of the Object." *Architectural Research Quarterly* 6/2 (2002): 190-192.

Stonard, John-Paul. "Hans Josephsohn." *Artforum* (2008): 454.

Unwin, Simon. "La Congiunta." In *Twenty-Five Buildings Every Architect Should Understand*, edited by Simon Unwin, 80-86. London, New York: Routledge, 2015.

AIR, WATER, AND EARTH
LESSONS ON COMMUNICATION FROM A MUSEUM IN THE MOUNTAINS
Michelle Dezember, Learning Director, Aspen Art Museum

LIVING in the mountains, despite the clear rhythmic forces of four pre-dictable seasons, I have come to expect unexpected weather. When we received more snow than forecast one particular night in December 2014, I accepted a ride home from someone I had just met at a holiday party. Samuel Bernal, who runs the Spanish-language radio station 107.1 La Tricolor, began asking me about my work at the Aspen Art Museum (AAM). We conversed in Spanish, and by the end of the ride we had devised a plan to host a quarterly family program. It was to be both on air at the radio station and at the museum under the title "Arte en Español." Having recently moved to this rural community after a lifetime of living in cities and working in big institutions, this was one of my early introductions to the power of person-to-person communication in small towns.

Founded as a non-collecting contemporary art museum in 1979, the AAM is the only art museum accredited by the American Alliance of Museums in the Western Slope of Colorado. The Western Slope of Colorado is a vast mountainous region that covers 47,000 square miles—almost half the state—and is located west of the Denver/Front Range Urban Corridor. This area is largely comprised of towns that have less than 6,000 inhabitants and are supported by tourism, construction, and energy extraction industries. The AAM is located here, at the top of the Roaring Fork Valley—an isolated fifty-mile area surrounded by the Rocky Mountains, only accessible by one road for much of the year. Although a popular perception of Aspen is of luxury and glamorous ski culture, its year-round community is much more complex. The Valley's working community, much like the rest of the Western Slope, often suffers from gaps in access to resources. For example, 46 percent of all students in the Valley's school district qualify for free lunches and in

neighboring school districts nearly one-third of the schools are official-
ly recognized as disadvantaged with Title 1 designation.[1] The region's
large Latinx population—which has doubled in the last ten years to 30
percent—is particularly vulnerable to need. According to a 2013 report
by the Colorado Children's Campaign, more than half of the state's chil-
dren in immigrant families live in poverty at a rate that is growing faster
than the national average.[2]

Installation view: *The Blue of Distance*, 2015. Photo: Tony Prikryl

While a diverse socioeconomic climate is familiar to museum work-
ers who have worked in cities and large metropolitan areas (such as
myself), addressing these diverse needs in rural areas spread over vast
geographical areas requires a unique set of strategies that are largely
gained through experience. Working as the Learning Director at the
AAM, located at the intersection of a rural community and international
contemporary art, I have been afforded the opportunity to develop a
new set of communication skills reflective of life in the mountains. This
essay unpacks the development of the "Arte en Español" program as a

1. "Title 1, Part A," Colorado Department of Education, last modified September 22, 2016,
accessed January 4, 2017, https://www.cde.state.co.us/fedprograms/ti/a.
2. "Kids Count in Colorado 2013," Colorado Children's Campaign, accessed January 4, 2017,
http://www.coloradokids.org/wp-content/uploads/2014/12/2013-KIDS-COUNT-Updated-21.pdf.

case study, using encounters with artists and their work to offer lessons learned on the power of speaking, listening, and feeling from a museum at an elevation of 8,000 feet.

SPEAKING

THE air is thinner at higher altitudes. You have to move carefully and you become more aware of your body in space. Some joke that the lower concentration of oxygen encourages a craving for extreme activities like uphill races, winter sports, and paragliding. Perhaps this also translates to the search to be transported by art and culture. In the publication that accompanied the 2015 exhibition *The Blue of Distance*, AAM curator Courtenay Finn considered the work *Paper Moon (I Create as I Speak)* (2008) by Paul Ramírez Jonas. The installation consisted of a microphone, amplifier, and a lectern with a page taken from an adjacent picture of the moon tiled together by the remaining sheets of paper that repeat the phrase, "I create as I speak." This phrase, Finn explains, is an English translation of the Aramaic magical incantation, "Abracadabra," and serves as an invitation for visitor participation—it is a larger metaphor of the power of our reading of texts to connect us beyond our immediate reality.[3]

Within five months of our initial meeting, Samuel and I had aired several Spanish radio segments and connected with Ricardo Torres, a professor at Colorado Mountain College. As a specialist in Mexican gastronomy, he gave a presentation at the first "Arte en Español" event in Spring 2015, where he examined popular recipes, showed plant taxonomy diagrams, and read a poem on the art of cooking, all in the native language of the nearly 150 Latinx visitors. As some of the families were leaving, they came up to Samuel and I to express interest in continuing "Arte en Español." A woman whose children had previously visited on a field trip told me that she had never felt comfortable coming to the AAM, but hearing her language at the museum made the leap easier. She had been on the gallery tour and had spoken into the microphone of Ramírez Jonas's work *Paper Moon (I Create as I Speak)*, saying hel-

3. Courtenay Finn, *The Blue of Distance* (Aspen: Aspen Art Museum Press, 2015), cxxvi.

lo to her children and her family—some in the museum with her, and some presumably far away. Ramírez Jonas's work is a manifestation of the ability of language to transport us to places otherwise inconceivably distant. "Within other people's words," Finn's curatorial essay asserts, "we are able to journey beyond our imagination, navigating distances normally impossible within the constraints of time and space."[4]

Large distances often make those living "off the beaten path" feel small, isolated, and alone—especially when the voices we hear come from large communities in cities. However, the reading of a text (words, images, etc.) in the social setting of a shared gallery experience creates correspondence across different spaces, times, and subjects that enhances connectivity to a world larger than our geographical bounds. Just as the radio broadcasts empower families to visit the museum through promotional and educational messages, the atmosphere becomes alive with possibility whenever the air is filled with museum visitors' meaningful conversations. Who do we allow to speak at the museum, and how can these voices breathe new life, creation, and connectivity into the community?

Chalkboard drawing of the Colorado River as an artery inside
107.1 La Tricolor recording studio

4. Ibid.

LISTENING

WHEN thinking about communication, speech is often the first action considered. The work of artist Robert Sember, and the larger practice of the sound collective Ultra-red that he belongs to, pays attention to the power of listening, observing that "political speech is seldom the pinnacle of political power."[5] Rather than being a passive act, listening allows us to fortify and diversify our knowledge. When Robert came to visit Aspen in summer 2015, we discussed "Arte en Español." He drew a poetic comparison between the way the radio waves carried information to the Spanish-speaking community and how the flow of the Colorado River connects the Roaring Fork Valley to Mexico, the country where a majority of the "Arte en Español" participants originated. Robert encouraged me to consider the work of Allan Kaprow, an artist whose writings are featured in publications and books in the AAM gift shop. Kaprow famously staged "Happenings" to enact his belief in the blurred boundaries between art and life. In a 1975 Happening, "ECHO-LOGY," Allan convened a group of people to redistribute water in a river:

> Carrying some downstream water
> a distance upstream
> bucket-by-bucket
> pouring it into stream.[6]

"ECHO-LOGY" focuses on human interaction with natural processes. By observing and repeating the actions of the river, participants consider what can be gained from the position of another. This consideration is active; Kaprow is considerate in the language he uses to record this Happening: "It's printed language is sparse, its repeated *-ing* verb endings convey a continuous present."[7]

5. Robert Sember, "From Hearing to Listening: The Sound of Community Organizing" (paper presented , at The New School, New York, New York, May 14, 2016), https://www.youtube.com/watch?v=EematiFeDAI.
6. Allan Kaprow, *ECHO-LOGY* (New York: D'Arc Press, 1975), 1.
7. Allan Kaprow, "Nontheatrical Performance," in *Essays on the Blurring of Art and Life* (Berkeley and Los Angeles: University of California Press, 1993), 165.

In a February 2016 edition of "Arte en Español," we invited con-
struction workers to present images of their work, sharing photos of
buildings, landscaping, and plumbing as works of careful artisanal ac-
complishment. One man presented pictures of himself working on the
still-under-construction gallery walls of the new AAM building, providing
an insight into another aspect of the museum that I otherwise would
not have seen. By listening to these presentations, I gained an appreci-
ation of the depth and breadth of the contributions of our community
that, until now, I had not been entirely aware of. In his lecture at the
2016 MuseumNext conference, Mike Murawski encouraged flipping our
understanding of "outreach": "We fight so hard for outreach and get-
ting out into the community, but sometimes we just need inreach—a
way for us at the museum to open our ears, open our hearts, and let
others in, let others get involved in new and different ways."[8] Listening
is an active process, perhaps even more engaged than speaking. Mu-
seums can greatly benefit from Robert Sember/Ultra-red's protocols
for radical listening, inviting our communities to speak and then asking
ourselves, "What did you hear? How did you listen?"[9]

FEELING

THE acts of speaking and listening rely on intuition; creating words to
speak must come from an internal knowledge, while receiving words
through listening requires careful discernment. This awareness is both
necessary and automatic. In a memorable contribution to the AAM
exhibition *Second Chances*, artist Helen Mirra walked every morning
between April 13 and May 1, 2015, across Aspen with or without the pub-
lic to whom she extended an open invitation. I joined Mirra one snowy
April morning. She gave me very simple instructions: walk for two hours

8. Mike Murawski, "The Urgency of Empathy and Social Impact in Museums," *MuseumNext*,
November 15, 2016, accessed March 10, 2017, https://www.museumnext.com/insight/empa-
thy_social_impact_in_museums/.
9. Ultra-red, "Organizing the Silence," in *On Horizons: A Critical Reader in Contemporary Art*,
ed. Maria Hlavajova, Simon Sheikh, and Jill Winder (Utrecht: BAK, 2011), 192-209.

considering an invitation to evoke the "half-smile" as described by Thich Nhat Hanh:

> the half-smile is both autonomous and intended toward other beings and things,
> the half-smile is not a grin or a smirk,
> the half-smile is both a substantial commitment and an easy employment,
> the walking is both a substantial commitment and an easy employment,
> the walking is not competitive or documented,
> the walking is both regardless of and regarding the weather.[10]

As I walked through several inches of snow, I considered the natural movements of my feet upon the earth and how they were "a substantial commitment and an easy employment." This balance, achieved by allowing the intuitive process to unfold, is perhaps also the balance required for successful museum initiatives seeking a serious, intimate commitment to a great number of people. Like walking, like a half-smile, learning in museums should require exerting effort with a sincere naturalness.

I consider this when thinking of our most recent "Arte en Español" event. While viewing works by Gabriel Orozco, the families connected less with his Mexican heritage than with the themes he explores in his work, such as cycles of life, nature, and human experiences. A large group stayed with me in the gallery, longer than I had anticipated. They traced their fingers in the air over the many circles found throughout Orozco's paintings and sculptures. They spoke amongst themselves and sometimes with me. Most importantly, though, they spent time looking, thinking, and experiencing that which could not be immediately explained. How do we create the space to dig past the surface experience of an artwork or exhibition?

10. Helen Mirra, *Half-Smiler (Colorado)*, 2015, accessed March 10, 2017, http://www.hmirra.net/information/pdfs/halfsmiler_CO.pdf.

Participants of "Arte en Español" in the exhibition *Gabriel Orozco*, November 2016

CONCLUSION

THE gifts of my small, intimate Aspen environment—both of nature and of contemporary art—have provided models for engagement and interaction. I share these lessons from a museum in the mountains, where the air moves voices across disparate distances, the water responds to the forms of its surroundings, and the earth provides support for us to stand truthfully in the present. These interactions between artists, institution, and community members provide examples of the speaking, listening, and feeling I have outlined. These are all rooted in their place, yet are mindful of their connections to the outside. I never forget that I am living in the mountains; their presence humbles me every day. But the museum provides a conduit for me to communicate and connect with a broader audience than I could ever imagine. Whether these lessons speak to the similar experiences of others working in small, rural communities or provide new perspectives to large, urban institutions, there is still much to be learned about communication from our environments.

BIBLIOGRAPHY

Colorado Children's Campaign. "Kids Count in Colorado, 2013." Accessed January 4, 2017. http://www.coloradokids.org/wp-content/uploads/2014/12/2013-KIDS-COUNT-Updated-21.pdf.

Colorado Department of Education. "Title 1, Part A." , Last modified September 22, 2016. Accessed January 4, 2017. https://www.cde.state.co.us/fedprograms/ti/a.

Finn, Courtenay. *The Blue of Distance*. Aspen: Aspen Art Museum Press, 2015.

Kaprow, Allan. *ECHO-LOGY*. New York: D'Arc Press, 1975.

———. "Nontheatrical Performance." In *Essays on the Blurring of Art and Life*, 163–180. Berkeley and Los Angeles: University of California Press, 1993.

Mirra, Helen. *Half-Smiler (Colorado)*. 2015. Accessed March 10, 2017. http://www.hmirra.net/information/pdfs/halfsmiler_CO.pdf.

Murawski, Mike. "The Urgency of Empathy and Social Impact in Museums." *MuseumNext*, November 15, 2016. Accessed March 10, 2017. https://www.museumnext.com/insight/empathy_social_impact_in_museums/.

Sember, Robert. "From Hearing to Listening: The Sound of Community Organizing." Paper presented at The New School, New York, New York, May 14, 2016. https://www.youtube.com/watch?v=EematiFeDAl.

Ultra-red. "Organizing the Silence." In *On Horizons: A Critical Reader in Contemporary Art*, edited by Maria Hlavajova, Simon Sheikh, and Jill Winder, 192–209. Utrecht: BAK, 2011.

OPEN TABLE
Roni Packer

HOME is an assumed incubator of gender roles, a space of traditional routine, but also a site of insurrectionary praxis. "Opening a table" is a common term in the place where I come from.

As a woman, one is expected to know how to "open a table", which means that she is measured by her cooking skills and generosity.

From a young age, I was inventing different measurements and scales for myself. One of them included drawing a circle. A year ago, I finally gave up and bought myself a pair of compasses.

IMAGES ON THE FOLLOWING PAGES:

1. *Triangle*, 2015 oil on panel, 11" x 14"
2. *Circle*, 2015 oil on panel, 11" x 14"

HONG KONG IDENTITY
UTILIZING THE SMALL TO CHALLENGE THE BIG
Benjamin J. Hruska

A permanent exhibition at the Hong Kong Museum of History entitled *The Story of Hong Kong* interprets a multitude of topics, including geologic and natural history, early human history, and the rapid transformations of the 20th Century. This exhibition demonstrates the design and fabrication of a bold concept with six years in development, showcasing over 4,000 objects, using hundreds of historical images and dioramas, and boasting eight galleries that display bilingual text panels. The timeframe of *The Story of Hong Kong* is equally grand. The narrative commences with the formation of the land masses making up the coastal area, and ends with Hong Kong's reunification with the People's Republic of China (PRC). At first glance, this is a big story told in a big way, and the scale of this exhibition may make it an unlikely candidate for a journal issue celebrating the "small." However, the discerning eye picks out the thread of the small in this large narrative. Much like a jigsaw puzzle containing small amounts of space that allow pieces to fit together, a large exhibition covering a massive timescale also retains curatorial space between thematic topics. This places curators in a unique position. That is to say, by utilizing the art of subtlety, curators can publicly present an exhibition narrative that differentiates Hong Kong from mainland China.

The curators of *The Story of Hong Kong* faced a big challenge in the scale of the narrative they were seeking to interpret. While small in size, Hong Kong throughout history has served as a magnet for new peoples, concepts, and ideas; thus, these curators had to interpret Hong Kong not in a bubble, but as part of the interconnected global community. Along with such major urban centers as London, New York City, and Tokyo, Hong Kong functions as a crossroads for cutting-edge concepts in technology, architecture, and fashion. Walking the streets

of this city center, one can see human migrations, including people of Indian, European, and Chinese descent. Dazzling lights, seas of people ebbing and flowing, and a cornucopia of honking erupting from mopeds and cars all point to an amazingly high population density of nearly 7,000 people per square mile. This Special Administrative Region (SAR) of the PRC is just 425 square miles, but holds a population of over 7 million residents.[1] The curators needed to consider this blending—of peoples, technologies, and religions—in the fabrication of this exhibition.

Nevertheless, beyond the high-rises that echo modernity, a sense of smallness persists in Hong Kong, as it views itself. And history of course is a central component of any self-reflexive action. An author of fiction, exploring the soul of this place in the 1980s, coined the phase "a floating city."[2] This analogy points to the transition underway at the time, from the mixture of control and culture that tethered Hong Kong to the British Isles ending, to the movement toward the unknown reunion with the communist mainland of China. Like a pawn in a game of chess, this small outpost, with a big economic influence, was morphing from one sphere to another. Such an occurrence, of being ruled by one global power and seamlessly heading over to another, makes a people feel small. One noted scholar suggests that Hong Kong identity is binary. The roots of this specific cultural space extend much deeper than just the obvious three binary pairings of East and West, traditional and modern, and Cantonese and English. Historically, Hong Kong has functioned as a doorway, as a place for transit, and thus inherits a unique history. Moreover, it also produces a sensation of smallness, as outside global forces have continuously shaped and reshaped both the physical and psychological landscapes.[3] The briefest of historical sketches of the past 170 years clearly demonstrates this notion, which is reflected in the exhibition *The Story of Hong Kong*.

Starting in the early 1840s, the small indigenous fishing village from which Hong Kong would spawn witnessed radical change with the

1. "GovHK: Hong Kong – the Facts," GovHK, accessed December 6, 2016, http://www.gov.hk/en/about/abouthk/facts.htm.
2. Xi Xi, *Marvels of a Floating City and other Stories* (Hong Kong: The Chinese University Press, 1997).
3. Ackbar Abbas, *Hong Kong: Culture and the Politics of Disappearance* (Hong Kong: Hong Kong University Press, 1998).

establishment of British military and economic presence. In World War II, the Japanese invaded and violently attempted to reshape the city in their image. In the postwar period, lacking any self-determination under British rule, the inhabitants poured their energy into making Hong Kong an economic powerhouse. Then, in the mid-1980s, the British government and the PRC began discussing the handover of sovereignty to the communist nation. This formal handover took place in 1997. Hong Kong then faced the process of shedding the identity of a British outpost and merging with that of the massive communist nation adjacent to it. While the handover included a fifty-year delay on any major transformations in Hong Kong's legal status, the resulting uncertainty created fears for accumulated wealth, ways of life, and individual freedoms.

Walking to the museum, visitors see stunning views of skyscrapers that would have been unthinkable just fifty years ago. Curators faced the challenge of telling a story that that bears witness to a physical transformation of the city, which is hard to grasp. Since the 1960s, the neighborhood of the museum has witnessed repeated razings to build larger and taller buildings, while the economic impact of these changes have caused ripples on the global scale. But beyond constructing a curatorial narrative that can effectively summarize a vast amount of change in a small amount of time, curators faced the added challenge of the production of an exhibition where the freedom of expression enjoyed under the British is eroding with the merging with the PRC.

Presenting history in China requires the skill of subtlety. In sharp contrast with those in the museum field in North America, these museum practitioners understand the pressure a national governing authority can impose in order to make life very difficult for any institution or individual disseminating information deemed critical of the government. While in North America, an exhibition shedding light on an unpopular aspect of history can produce letters to an editor or threats of cuts to future funding from businesses and individual donors, the PRC will actually shut down an institution that has been branded a threat. The employees at the Hong Kong Museum of History need only consider a neighboring museum in this corner of Kowloon to understand this statement loud and clear.

In 2016, a small museum in Hong Kong called the June 4 Memorial Hall was forced to close its doors. This was the world's first museum dedicated to memorializing the 1989 crackdown on protestors in Tiananmen Square. The governing authority of the museum was a group called the Hong Kong Alliance in Support of Patriotic Democratic Movements in China. Besides this recently closed museum, the group is most known for the massive Tiananmen anniversary vigil held every year in Hong Kong. On the forced museum closure, the *Guardian* reported, "Tenants in the commercial building housing the museum say it breaches regulations because the premises should only be used for offices."[4] The museum leadership thinks political pressure from Beijing is behind their eviction, and they point to the fact that more than half of the museum's 20,000 annual visitors were from mainland China, where the dissemination of any information on the crackdown is illegal.[5] Thus, the closure of a museum across the street due to perceived government pressure certainly could make any curator feel very small. Political pressure from Beijing is slowing chipping away at the freedom of expression enjoyed under British rule with restrictions of the press in Hong Kong. Curators, as guardians to the narratives of public history, understand these increasing constraints echoing south from the mainland.

In viewing an exhibition of this scale, it is easy to forget that this is local history. The power of local history is especially potent in places like Hong Kong, where for the last 50 years economic growth has decimated buildings as the real estate space above any aging business district becomes so valuable that wrecking balls soon emerge and skyscrapers appear. However, public buildings, such as schools, buck this trend. Thus, schools are some of the oldest buildings seen on the walk to the museum itself. One school proudly displays a historical marker noting that it was the boyhood school of film star and local legend Bruce Lee.

Curators utilize this tactic of examining the intimate aspects of life in the exhibition's exploration of local history, and in doing so allow for the subtle investigation of the global forces shaping Hong Kong in the

4. Agence France-Presse, "Hong Kong's Tiananmen Square museum to close amid claims of China pressure," *The Guardian*, April 14, 2016, accessed December 8, 2016, https://www.theguardian.com/world/2016/apr/14/worlds-first-tiananmen-museum-close-hong-kong.
5. Ibid.

postwar period. Where local history falls short in attempting to shed light on the economic miracle that took place in the 1950s and 1960s, the use of the small is not abandoned in addressing important aspects such as the Cold War, capitalism reshaping the Pacific Rim, and global shipping. Rather, by exhibiting the modest products manufactured for the Western world's smallest consumers, the curators usher in a thoughtful discussion about the birth and development of a single global economy that has coalesced in the latter half of the 20th century.

A green plastic water pistol, a small brightly colored roller skate, an electronic racecar set with corresponding track—all these objects demonstrate the rapidly transforming economy of Hong Kong that commenced in the 1950s. These objects, much like the individual bilingual text labels next to them, accomplish two tasks simultaneously. First, these toys showcase a window into the global history of shipping and receiving. Middle-aged visitors from the West immediately recognize toys they had (or wished they had) when they stare into the glass cases. Second, on a much subtler level, these small toys demonstrate the very different path Hong Kong was on during the 1960s in comparison to that of mainland China. While untold millions were dying in the hellish realities of Mao's Cultural Revolution, Hong Kong's nascent manufacturing base was accelerating in a different direction, toward prosperity. While no exhibition in Hong Kong can brazenly hit the visitor over the head with such a statement in print form, these small toys contrast sharply with the reality under Mao's regime, just miles away to the north.

But of the thousands of coordinated objects displayed in this exhibition on the history of this place, including rice cultivation, geologic history, and ebbing and flowing Chinese dynasties, the end is the most stark. Apart from the facts surrounding the official handover of sovereignty in 1997—such as a large screen displaying the symbolic transfer with a British vessel, decks festooned by dignitaries waving goodbye to the last vestiges of Empire—nothing is interpreted. This is beyond small, as Hong Kong and the PRC are in the realm of the unseen, the unknown. This is no accident, and it mirrors life outside the museum doors that one sees after exiting *The Story of Hong Kong*. A large mockup of the signed agreement is the last display. Hong Kong is 20 years into the 50-year purgatory when the formal merging with the mainland will take

place. Fractures are already visible and forecasts indicate that this will not be a smooth path toward the year 2047. Citizens of Hong Kong resist in small ways, speaking Cantonese rather than Mandarin, retaining their own currency with no images of Mao, and operating a legal system that is steeped in the British tradition. Public spaces devoted to the display of history, whether in an exhibition or a history textbook, are vulnerable to Big Brother seeking influence. However, relying on the art of subtlety in exhibition and interpretation allows curators to harness the power of the "small" to pivot Hong Kong's identity, distinguishing it from that of the People's Republic of China.

BIBLIOGRAPHY

Abbas, Ackbar. *Hong Kong: Culture and the Politics of Disappearance*. Hong Kong: Hong Kong University Press, 1998.

GovHK. "GovHK: Hong Kong – the Facts," Accessed December 6, 2016, http://www.gov.hk/en/about/abouthk/facts.htm.

France-Presse, Agence. "Hong Kong's Tiananmen Square museum to close amid claims of China pressure." *The Guardian*, April 14, 2016. Accessed December 8, 2016, https://www.theguardian.com/world/2016/apr/14/worlds-first-tiananmen-museum-close-hong-kong.

Xi, Xi. *Marvels of a Floating City and other Stories*. Hong Kong: The Chinese University Press, 1997.

THE FINE ART OF REDUCTION
DIMINISHMENT, DISTANCE AND TAYLORS PANORAMA OF SYDNEY
Meighen S. Katz, University of Melbourne

ON my bookshelf, amidst books on architecture and urban history I have a collection of models, each a famous urban landmark in miniature. The Sydney Harbour and Golden Gate Bridges take rough shape: tiny plastic blocks, while a little Tate Modern shines in flimsy pressed tin, and the Chrysler building doubles as a picture clip. In contemplating them, the word reduction comes to mind: the reduction of a diverse multi-faceted city into a single iconic building; the reduction of that landmark building to the size of a packable souvenir. Up until this point, I had not particularly thought of curating as reductive process, but clearly this is an aspect of curatorial work. We reduce centuries of human history to a few representative objects. Soaring glacial peaks and vast oceans are corralled into gilt-edged frames. All of time and space is shrunk so that it may fit into designated buildings and then again into specific galleries, and once more into a labeled case. We reduce our collections of material and visual knowledge to their component parts. One of the arguments in favor of shrinking knowledge, concepts and our collections down to scale of display is to make all of them more accessible and less overwhelming. But is the process of reduction accompanied by diminishment? Can we achieve reduction of scale without reducing the power of the ideas and objects we seek to interpret?

I am particularly cognizant of the question because I have spent the last few months as a member of the curatorial team for a comparative exhibition of American and Australian landscape art. This has been unfamiliar territory for an urban historian, I must confess. The subsection for which I am primarily responsible consists of prints reflecting the urban development of Sydney and Melbourne, Australia's largest cities, across the 19th century. Many of the Australian prints were initially designed as illustrative plates in books or as pre-photographic images

for periodicals and their size reflects their domestic intents. The exhibition brief calls for them to be hung in proximity to landscapes that are immense in both scale and content. My reaction is akin to that of a protective, possibly overprotective, stage parent. Will my small prints be able to maintain their individual value? In my darker moments, I fear the prints will become filler, simply breathing spaces between the more impressive canvasses.

Though now sized for domestic display, several of the Australian images were once displayed on a much grander scale. A topographic panorama of Sydney's early urban development, based on paintings by Maj. James Taylor in 1821, is one such example. Taylor, a member of the 48th Regiment, served in Australia between August 1817 and July 1822.[1] Upon his return to London, he successfully sought to have his watercolors published for sale. The work also came to the attention of James Burford who adapted it for exhibition in his panorama rooms in Leicester Square in 1823.[2] Though greeted with some disdain by established landscape painters, the panorama was popular with the general public and remained a going concern well into the middle of the 19th century. [3] The viewer entered the panoramic rooms from below, ascending to a suspended viewing platform that allowed the audience to be fully surrounded by the view. Taylor's depiction of Sydney proved to be popular and the panorama was reproduced as a triptych of prints engraved by Robert Havell and published by the Colnaghis in 1823, who sold them in both England and Australia.[4] These various reproductions of the view also speak to an image's fluidity of scale. Taylor reduced a far-reaching view of Sydney into a watercolor, which was in turn enlarged to give Burford's patrons an immersive experience, only to be once again reduced so that Colnaghis could market it to the public. In my flights of greater fancy, I contemplate suggesting that our Taylor prints be enlarged to mimic Burford's immersive panorama. Such scale would allow the images a fighting chance against the more traditional landscapes. I

1. Gordon Bull, "Taking Place: Panorama and Panopticon in the Colonisation of New South Wales," *Australian Journal of Art* 12 (1994-95): 86.
2. Bull, "Taking Place," 86; Allison Holland, "Robert Havell Jnr," in *This Wondrous Land: Colonial Art on Paper*, ed. Alisa Bunbury (Melbourne: National Gallery of Victoria, 2011), 78.
3. Ibid, 78.
4. Ibid, 86.

suspect, however, that even if I could convince the leaders of our cura-
torial team, budget considerations would constrict my grand aspirations.

Beyond the scale of the image, there is another process of re-
duction at play within the history of Taylor's landscape, and it is the
more significant one. Taylor's triptych is indicative of the ongoing visual
exchange between Australia and England within their broader imperial
relationship. There was a strong demand in Great Britain for illustrated
narratives as well as individual prints from Sydney and the rest of the
New South Wales colony. The visual and textual recollections of the
officer class, like Taylor, Lt. Robert Dale and Lt.-Col. Godfrey Mundy,
provided much material for the British printers and publishers.[5] Ad-
ditionally, this specific panorama was part of a larger course of action
which sought to address both the stigma associated with a penal colony
and the impact of the vast geographic distances between Britain and
the colony.

Though most famous as a destination for Britain's convicts, the
New South Wales colony was never simply a remote prison. It was al-
ways intended to be a commercial enterprise and a strategic bastion of
the British Empire. For either purpose to succeed, the colony had to be
understood at home and abroad as an extension of its nation of origin;
British if not entirely Britain.[6] However, the mix of military officials, free
settlers and convicts created a strange social structure.[7] The case for
the colony as Britain in remove was not aided by the 1808 actions of the
British army in the form of New South Wales Corps, who in response
to attempts to limit their control of colony's rum trade, deposed the
serving governor, Captain William Bligh (of *Bounty* fame). Coupled
with the so-called 'convict stain', New South Wales was perceived as
a decidedly foreign, most unruly, land that, in the first instance, could
not have been less like Britain. Bligh's successor, Col. (later Maj.-Gen.)

5. Michael Rosenthal, "The Penitentiary as Paradise" in *Double Vision: Art Histories and Co-
lonial Histories in the Pacific,* ed. Nicholas Thomas and Diane Losche (Cambridge: Cambridge
University Press, 1999), 40-43; Roger Butler, "Printed Images of New South Wales: London
and Sydney 1800-1820" in *This Wondrous Land: Colonial Art on Paper,* ed. Alisa Bunbury
(Melbourne: National Gallery of Victoria, 2011), 44-47.
6. Mark Peel and Christina Twomey, *A History of Australia,* (Basingstoke: Palgrave Macmillan,
2011) 32.
7. Peel and Twomey, *A History of Australia,* 26, 40.

Lachlan Macquarie was charged by the members of the British Foreign Office with establishing and cementing a sense of civility in Sydney and its surrounds. He did so initially with a campaign for public morals, but especially through an extensive public works agenda.[8]

Taylor was reportedly close to Macquarie and his work reflects Macquarie's civilizing efforts in both landscape and inhabitants.[9] Despite the use of rum as a substitute currency in the early colony, there is little in the representations to suggest the consumption of alcohol, let alone the consumption to excess.[10] Sydney town as here depicted is very much in the neo-classical vein of the 'New Rome'; an ordered town housing amiable citizens. [11] Windmills, barracks, a military hospital and similar institutional buildings as well as a flourishing port and additional building in process, create an atmosphere of order and unimpeded commerce. Nor is this simply a topographic diagram; this town is fully populated. Within the print we see active military and patients within the grounds of the military hospital, men at work and Indigenous Australians as well as a pair assumed to be Maori or Polynesian Islanders. The creation of domestic space–the cottage yard–in the left-most print makes use of women as a bell-weather, the presence of the officers ensuring that the mores of civilized society are observed and the women can go about their tasks unafraid of either convicted or Indigenous men.[12]

Thus, those who had been diminished in the eyes of fellow Britons become restored as peaceable, respectable and respectful of the conventions of law, both as citizens and enforcers. They may live amongst the native peoples, but they have not succumbed to the temptation to throw off the restraints of civilization. To the contrary, Taylor's far-flung Britons have influenced the earlier occupants to such an extent that they too now move easily amongst the streets and buildings. It is a

8. Peel and Twomey, A History of Australia, 40; N.D. McLachlan, "Macquarie, Lachlan (1762-1864)"Australian Dictionary of Biography. http://adb.anu.edu.au/biography/macquarie-lachlan-2419, accessed December 30, 2016.

9. Elizabeth Ellis, "James Taylor: Biography", Design & Art Australia Online. https://www.daao.org.au/bio/james-taylor/biography/ , accessed December 30, 2016; Rosenthal, "The Penitentiary as Paradise," 121.

10. Peel and Twomey, *A History of Australia*; Rosenthal, "The Penitentiary as Paradise,"111.

11. Bernard Smith, *European Vision in the South Pacific,* 2nd Edition, (Sydney: Harper& Row, 1984),178-180; Rosenthal, "The Penitentiary as Paradise," 121.

12. Bull, "Taking Place," 91.

fictive utopian vision, one that obscures the inherent violence in the col-
ony, enacted sexually and physically against convicts male and female,
and with genocidal results against the Indigenous population. Yet fiction
is almost to be expected; Taylor is not creating documentary, he is engag-
ing in what we in modern parlance might call a public relations exercise.[13]

In this light, Taylor's depiction with its sense of order, amiability and
imperial institutions can be read an act of conscious, active, reduction.
Even unruly nature itself is brought into line. The kangaroo, a celebrat-
ed discovery on the new continent, is contained in a cottage-yard and
bears closer resemblance to a small dog or a large rat. The creature is a
synecdoche of the colony's seemingly exotic environment transformed
into the recognizable and ordinary[14] Taylor's partnership with Burford's
establishment would have further served the goals of acceptability. The
immersive qualities of the room would create the illusion of familiarity
with the topography of Sydney, reducing the lengthy isolating voyage
that separated it from London to the simple act of ascending a flight of
stairs. Thanks to Taylor and Burford, Sydney could be seen as a 'here'
rather than 'there', and its inhabitants once again 'us' rather than 'them'.

The exhibit of Taylor's work in the 1820s served as both entertain-
ment and a political act designed to reduce perceptions of distance.
But the desires that led to the image's creation and then magnification
to life-size scale no longer exist. Australia no longer looks to Britain for
approbation and its citizens are more likely to turn to the internet than
a painting to reduce the tyranny of distance. Certainly, the panorama
does not commend the attention that it once did, but it has not been
reduced to complete insignificance. Displaying the work in the 21st cen-
tury once again serves to make a remote group of people seem acces-
sible, though in this case the overwhelming distance is temporal rather
than geographic. Taylor's panorama, despite being a work of fiction,
indeed because it is a work of fiction, gives modern museum audiences

13. In contrast, the observations of Lt-Col. Godfrey Mundy, while still decidedly imperial
in their tone, are more forthcoming as to the punitive hardships faced by convicts and the
violence suffered by Indigenous Australians; particularly, though not exclusively, those who
resisted the seizure of their lands. Godfrey Mundy, *Our Antipodes, or, Residence and Rambles
in the Australasian Colonies : With a Glimpse of the Gold Fields,* (London, Richard Bentley,
1852), 100-101, 105, 108.
14. Bull, "Taking Place," 91.

some insight into the fears and mindsets of their 19th century counter-parts. They may not be recognized with the sense of familiarity Taylor hoped the Sydney-siders would arouse amongst Londoners, but they do become that little bit more understandable.

As for my ongoing concerns as to whether these prints will be diminished by a display alongside the large oil paintings, only time will tell. Certainly they are less visually striking, possessing less grandeur than the larger canvasses. Much of their power comes not from their ability to stop a museum visitor in their tracks but in the narratives of their creation, distribution and display. Our exhibition, like all good exhibitions, is an experiment, one that relies on its own specific type of reduction. Prints like the Taylor triptych benefit from an approach more commonly associated with history exhibitions. Yet often historians seem as reluctant to draw in artistic objects as curators are to delve into the complications of history. Thus our exhibition seeks to reduce the gulf that often exists between different styles, of display. We aim for en-hancement from this reduction, a broadening of potential readings for the art, a broadening of approaches for the practitioners, and a broad-ening of understandings for the audiences. We hope that by making the disciplinary distinctions between art and history a little bit smaller, less will indeed be more.

BIBLIOGRAPHY

Bull, Gordon. "Taking Place: Panorama and Panopticon in the Colonisa-tion of New South Wales," *Australian Journal of Art* 12 (1994-95): 75-95.

Butler, Roger. "Printed Images of New South Wales: London and Sydney 1800-1820". *In This Wondrous Land: Colonial Art on Paper*, ed. Alisa Bunbury, 44-47. Melbourne: National Gallery of Victoria, 2011.

Ellis, Elizabeth. "James Taylor: Biography", *Design & Art Australia Online*. https://www.daao.org.au/bio/james-taylor/biography/ ,accessed December 30, 2016.

Holland, Allison. "Robert Havell Jnr," in *This Wondrous Land: Colonial Art on Paper*, ed. Alisa Bunbury, 78-79, Melbourne: National Gallery of Victoria, 2011.

McLachlan, N.D. "Macquarie, Lachlan (1762-1864)"*Australian Dictionary of Biography*. http://adb.anu.edu.au/biography/macquarie-lachlan-2419, accessed December 30, 2016.

Mundy, Godfrey. *Our Antipodes, or, Residence and Rambles in the Australasian Colonies : With a Glimpse of the Gold Fields*. London, Richard Bentley, 1852.

Peel, Mark and Christina Twomey. *A History of Australia*. Basingstoke: Palgrave Macmillan, 2011.

Rosenthal, Michael. "The Penitentiary as Paradise". In *Double Vision: Art Histories and Colonial Histories in the Pacific*, ed. Nicholas Thomas and Diane Losche, 103-130. Cambridge: Cambridge University Press, 1999.

Smith, Bernard. *European Vision in the South Pacific*, 2nd Edition. Sydney: Harper& Row, 1984.

CAPTIONS FOR THE IMAGES ON THE FOLLOWING PAGES:

1. James Taylor (1785-1829, artist) Robert Havell & Son (1818-1828, engraver) *The entrance of Port Jackson, and part of the town of Sydney, New South Wales August* 1823
Published by Colnaghi & Co, London, 1823
aquatint, engraving and watercolour
39.2 x 57.4 cm (image) 45.5 x 59.8 cm (sheet, irreg.)
The University of Melbourne Art Collection. Gift of the Russell and Mab Grimwade Bequest 1973 1973.0383

2. James Taylor (1785-1829, artist) Robert Havell & Son (1818-1828, engraver) *Part of the harbour of Port Jackson, and the country between Sydney and the Blue Mountains, New South Wales* 1823
Published by Colnaghi & Co, London, 1823
aquatint, engraving and watercolour
39.9 x 58 cm (image) 50.6 x 67 cm (sheet, irreg.)
The University of Melbourne Art Collection. Gift of the Russell and Mab Grimwade Bequest 1973 1973.0382

3. James Taylor (1785-1829, artist) Robert Havell & Son (1818-1828, engraver) *The town of Sydney in New South Wales*
Published by Colnaghi & Co, London, 1823
aquatint, engraving and watercolour
39.3 x 57.5 cm (image, irreg.) 40.5 x 58.4 cm (sheet, irreg.)
The University of Melbourne Art Collection. Gift of the Russell and Mab Grimwade Bequest 1973 1973.0381

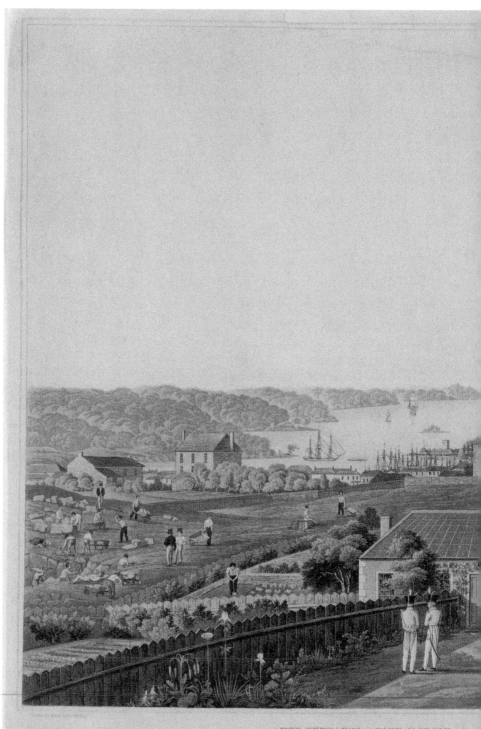

THE ENTRANCE OF PORT JACKSON, AND

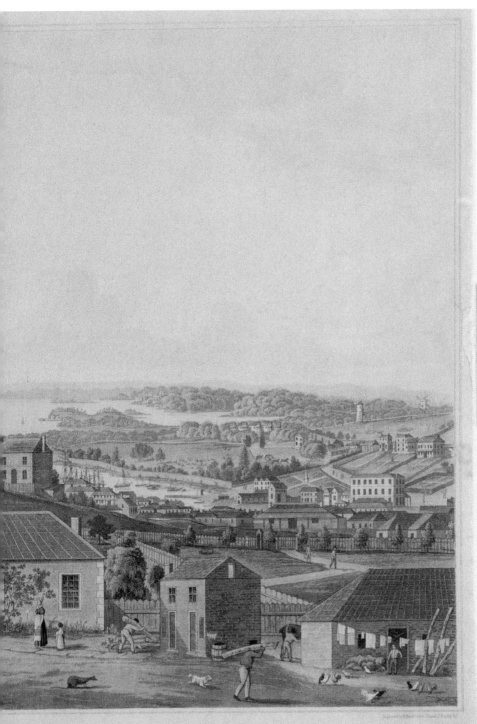

TOWN OF SYDNEY, NEW SOUTH WALES.

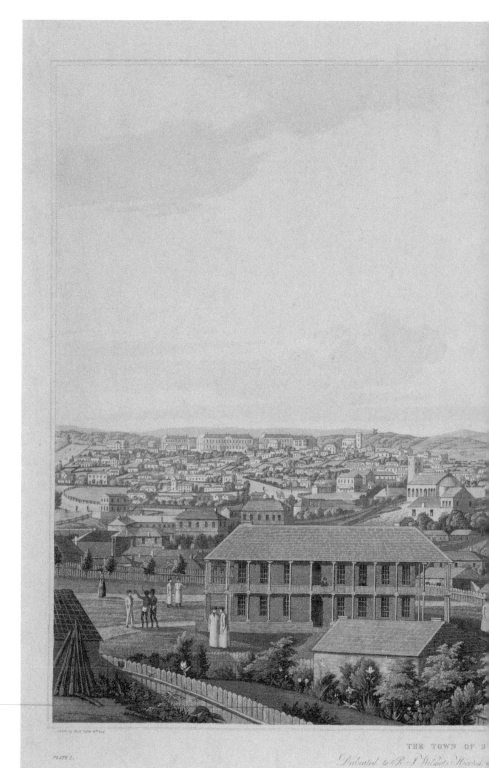

PLATE 2.

THE TOWN OF J

Dedicated to R. I. Wilmot Horton,

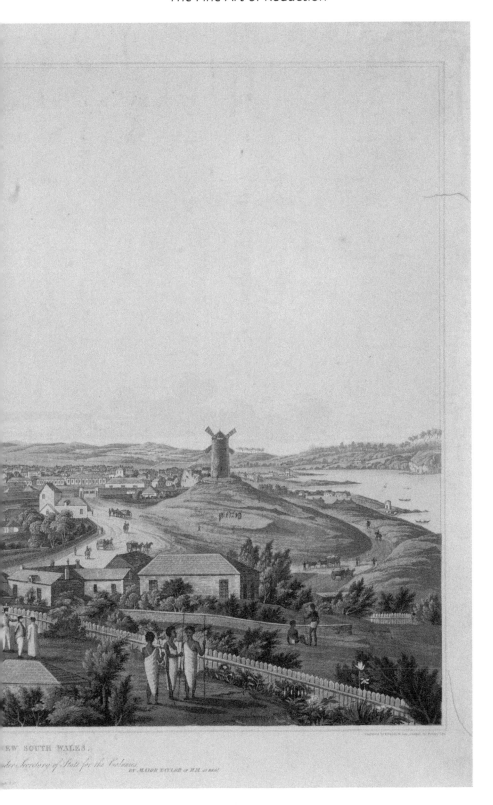

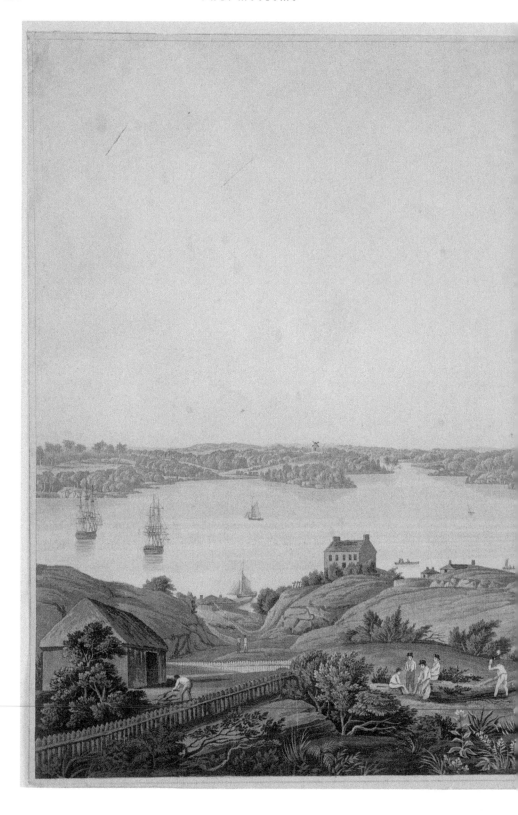

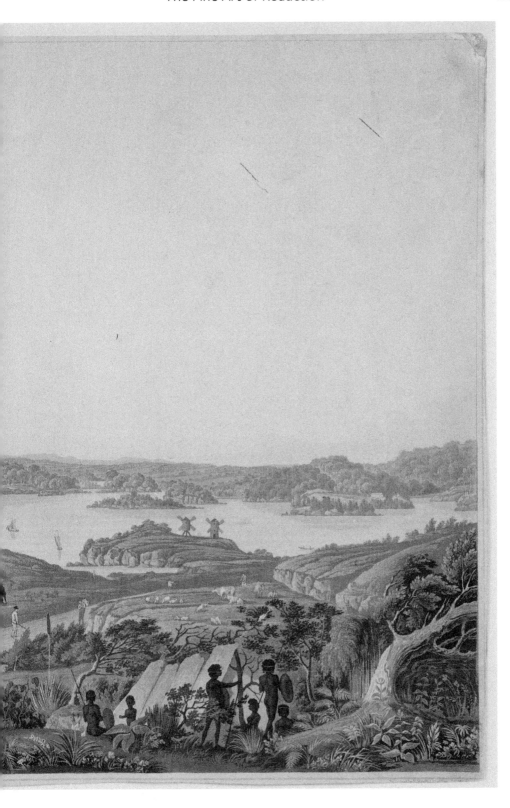

DISTURBING HISTORIES

BOOK REVIEW

Alexis Mixon

Museums, Heritage and Indigenous Voice: Decolonising Engagement.
By Bryony Onciul. Routledge, 2015. 267 pages. $105.25.

"It is your display, it is your story, you tell it your way."
-Frank Weasel Head[1]

BRYONY Onciul's *Museums, Heritage and Indigenous Voice: Decolonising Engagement* outlines the engagement practices of Alberta, Canada museums and the museums' relationships with the Blackfoot Confederacy of southern Alberta. Onciul's research seeks to "make a new contribution to the field through its emphasis on community participants' perspectives; the importance of inter-community collaborations; and the proposal of the concept of 'engagement zones'…[It] illustrates that sharing power is neither simple nor conclusive, but a complex and unpredictable first step in building new relations between museum and Indigenous communities."[2] Unlike the commonly used contact zone theory, the author's engagement zone theory is grassroots and cross-cultural. Contact zones are the space of imperial encounters, the space in which peoples geographically and historically separated come into contact with each other and establish ongoing relations.[3] In contrast, Onciul's engagement zones incorporate the inter-community work and cross-cultural nature that is prominent in grass-root community development efforts. For Onciul, engagement zones eliminate the neocolonialism endemic to contact zones because engagement zones'

1. Bryony Onciul, *Museums, Heritage and Indigenous Voice: Decolonizing Engagement* (New York and London: Routledge, 2015), 101.
2. Ibid., 2.
3. Ibid., 78.

ability to indigenize the process of internal community engagement.[4] Onciul uses her body of research to elevate the voices of Blackfoot Elders and the Blackfoot communities' members. Through *Museums, Heritage and Indigenous Voice*, Onciul and her collaborators advocate a reconfiguration of museum methodologies to tell the Blackfoot nations' stories of survivance.

The book begins with an overview of the four museums and inter-pretive historical sites Onciul uses as case studies: Head-Smashed-In Buffalo Jump Interpretive Centre World Heritage Site, Glenbow Muse-um, Buffalo Nations Luxton Museum, and Blackfoot Crossing Historical Park. The first chapter discusses Indigenous relations with museums across the globe throughout history. The second chapter gives a brief history of the Blackfoot Confederacy and an overview of religion/epis-temology, Blackfoot and Euro-Canadian contact, and the role museums took and continue to take in the storytelling and agency of the Black-foot people.

The Blackfoot Confederacy includes four nations: Kainai, Siksika, Piikani, and Blackfeet. Traditional Blackfoot territory extends from the North Saskatchewan River of Alberta, south to the Yellowstone River in Montana, from eastern Rocky Mountains to beyond the Great Sand Hills in Saskatchewan.[5] Contact with Euro-Canadians began as a mutual agreement with the fur and buffalo leather trade. However, Euro-Cana-dian and European demand for buffalo leather decimated the buffalo population, creating food scarcity and violating the Blackfoot spiritual value of balance. The Lame Bull Treaty of 1855 spearheaded the formal Euro-Canadian exertion of colonial policies over the Blackfoot. As a result, the federal government grabbed a significant amount of tradi-tional Blackfoot land, in the absence of Blackfoot representation, and compensated them with federal money to use within civilization and Christianization efforts. The Euro-Canadians used alcohol and disease to subdue Blackfoot resistance to colonial oppression.[6]

When annihilation did not work, the federal government attempt-ed assimilation. The government outlawed Blackfoot language and cul-

4. Ibid., 82.
5. Ibid., 44.
6. Ibid., 51-53.

ture and imposed English and Christianization. One of the most sensitive and devastating topics is the Residential School Era (1831-1996). The Canadian government ripped Blackfoot children from reservations and placed them in boarding schools where they suffered from overwork, unconscionable living conditions, and sexual assault. Museums actively served as extensions and enforcers of social control by representing Blackfoot peoples as savages and racist caricatures with no valid culture or spiritual/religious system. Contemporarily in Canada, due to centuries of systematic oppression, Indigenous people live within the lowest socio-economic range, work to reckon with their peoples' past, and deal with misrepresentation by mainstream Canadian histories. Museums hold responsibility in the perpetuation of prejudice against the Blackfoot and Indigenous peoples overall.

Next, the book shifts from historical overview to consideration of engagement, museum case studies, and museology. The third chapter unpacks the term "'engagement'" and proposes a new form of engagement that will reinvigorate decolonization and Indigenization. The fourth chapter analyzes the difficult particularities of museum/community relations, as well as the levels and techniques of engagement unique to each cultural institution. The fifth chapter, "Indigenizing Museology," makes clear that communities and museum professionals do not go into meetings and negotiations with a predetermined amount of power willing to be shared.

At its inception, Head-Smashed-In used consultation as a form of engagement with the local Blackfoot nations. The historic site engaged with the neighboring Piikani Reserve out of necessity rather than goodwill.[7] Museums are historically adjunct forms of government agendas and grand social schemes. The memory of colonial and modern paternalism is well kept among the Blackfoot communities of Alberta. Head-Smashed-In maintained a constrained relationship with Blackfoot communities and museum staff saw themselves as best fit to tell a story that did not belong to them. Head-Smashed-In perpetuated the paternalistic attitude that many members of the Blackfoot nations expect from museums.

7. Ibid., 138-139.

Contrary to Head-Smashed-In's engagement with the local Blackfoot nations, Glenbow Museum showed a willingness to reevaluate its museology. The museum co-curated the exhibition *Spirit Songs* (1988) with Blackfoot Elders and made earnest efforts to repatriate objects to the various nations on a national and international scale. Even so, trust needed to exist between the groups in order for an honest story and interpretation to come to fruition within the gallery walls. In a 2008 interview with Onciul, Elder Frank Weasel Head stated, "...there was always that question: What are they going to use it for? But when they kept coming in and saying no, it is your display, it is your story, you tell it your way. So then it started."[8] Glenbow Museum's open and fluid engagement with the Blackfoot nations' Elders exemplifies the author's theory of engagement zones.

Onciul openly admits to the limits of community engagement and the impossibility of reaching every individual. Yet, she emphasizes the importance of and the power in consistent effort to build relationships and a willingness to let those relationships develop organically. Blackfoot relationships with museums come from a long history of extermination and assimilation policies that sought to rid the Blackfoot peoples of their personhood and culture. Many members of the communities continue to oppose working with museums. Those who engage with the museums are seen as sellouts, thus straining relationships in the community. There is a distrust and anger toward museums for their past dehumanization of the Blackfoot peoples and many institutions' slow ability or willingness to recognize the ultimate authority of the Blackfoot peoples in telling their story. Onciul's research explores the complex reality of human communication and the voices that are lost and found in museum engagement.

Unfortunately, Onciul's argument and sources rely too heavily on interviews with Blackfoot Elders and high-level museum professionals such as curators, conservators, and registrars. The interviews did not represent the experiences of other museum staff or museum visitors. This oversight misses the opportunity to demonstrate the ability of engagement zones to educate Blackfoot individuals and people outside the Blackfoot communities. Although Onciul's engagement zone theory

8. Ibid., 101.

promotes and cherishes the organic nature of developing relationships and understanding, the theory requires statistics and demographic information and analysis. Without the latter, the engagement zone theory reads and conceptualizes as an overreach. It does not assure readers that the practice of the engagement zones reached anyone outside the museum profession, Blackfoot Elders, or leaders of the Blackfoot communities.

Overall, *Museums, Heritage and Indigenous Voice: Decolonising Engagement* challenges the museum engagement theory canon and serves as a medium for making the voices of the Blackfoot Confederacy heard. It advocates for museum workers to deconstruct their strictly categorized ideas and practices of engagement with communities. Where to from here? Onciul argues that museums need to listen to communities, not merely consider communities' knowledge and desires as advice. Instead, museums should be a forum or a channel for communities' voices to be heard, for their cultures to be celebrated through their voices, and for community self-preservation in the past, present, and future.

BIBLIOGRAPHY

Onciul, Bryony. *Museums, Heritage and Indigenous Voice: Decolonizing Engagement*. New York and London: Routledge, 2015.

SELECTIONS FROM FOCUSING (VOL II)
alejandro t. acierto

I.

OVER the last year or so, I've spent a lot of time thinking about the idea of breathing as an act of becoming. Emerging from earlier projects that considered the voice as a primary aspect of agency, the breath became a site that enabled the voice – a natural, bodily function that preceded speech and vocalization. For me, the breath was a pause, a momentary break that enabled the body to continue with its actions. There, in each pause, was a space from which we could re-make ourselves and push our bodies to continue to thrive. Taken another way, breathing, and the breath at large, became a way to think about endurance and exhaustion - particularly in the context of historically marginalized experience. For those of us who carry historical trauma of colonialism, racism, sexism, or any other form of marginalization, we bear the weight of our collective past. Within the broader strategy to reclaim our subjectivity, we develop survival tactics – endurance – to enable our lives to continue.

Our ability to sustain ourselves was and is contingent on our ability to breathe.

II.

AFTER weeks of searching for material on eBay, I stumbled upon a pair of images from the 1930's by an antique seller in Des Moines, Iowa. This curious set of images sold as a lot were listed as "1930s Luzon Philippine Islands Tagalog Native & Constabulary Officer Photos 2." A relatively incoherent jumble of search words, the items were part of a specific, yet vast collection of objects and ephemera available for sale from across the globe. Another object, "Bamboo Band rppc Music Flute Philippines

ca 1915", had come from the Netherlands, and yet another came from a small town in Wisconsin. While many of these objects found on eBay are highly regarded collectors items, I was interested in their recirculation and how they may have re-inscribed positions of the imperial moment. But as commodities that populate eBay's site, these ephemera don't seem to go anywhere as they sit waiting for an interested bidder to purchase it.

An "abject reliquary", eBay became a digital museum and collection from which I could begin to engage a project related to materializing the seemingly invisible. These small, often 4x6 inch images that were rich in content, propelled this work and drove its conceptual framework. Though housed in the idea and material of the breath, these relics of a "forgotten" war became a strategy through which I could begin to illuminate the structures of imperial logic that would comment on Filipino subjectivity. It was within these images that colonial structures were reflected and sustained, where the U.S. colonial imaginary could uphold their "benevolent assimilation", and where the Philippine-American War could be erased from the cultural memory of national formation.

Turning to the recent work of Nerissa S. Balce, she writes of this particular phenomenon as one located in the abject, as part of a larger narrative that situates the Philippine-American war as a "forgotten" war populated with relics of the imperial moment. In its effort to downplay U.S.-led imperialism as a "Filipino insurrection", Balce noted that this turn in language shifted the nexus of agency that enabled this particular colonial moment as a disposable, insignificant era in early twentieth century American history. In Sarita Echavez See's analysis, "the war did not happen; rather, the United States 'acquired' the Philippines." Furthermore, as See articulates, the language of "cession" and "acquisition" became a method through which US colonialists could conceal agency and effectively erase the cultural and political impact that the war had on the U.S. Positioning this abject-ness, eBay then became a site that housed the distribution of American imperial abjection through the circulation of the visual abject, or "every image, photograph, narrative, or cultural relic connected to a forgotten American imperial war in the Pacific...which launched the United States as an imperial power in Asia."

Images housed in the collections of the Library of Congress, the Smithsonian, and National Archives further projected this narrative that enabled the Filipino-as-human to disappear, to be rendered "savage" and inhuman. Catherine Ceniza Choy writes that these photographs on postcards were integral to the inscription of the "savage" Filipino and, quoting Fatimah Tobing Rony, "functioned as 'spatial and temporal bridges' from the Philippine colony to the imperial United States, enabling masses of Americans to consume the Philippines and its peoples visually." Rendering Filipino bodies as abject and savage, the reproductions that populated (and currently populate) the commercial space of the internet auction site seem to be a fitting location. As abject ephemera that are bought and sold, the postcards, photographs, or other material culture that circulate online thus double Modernism's imperial racist logic where bodies could be owned, traded, and consumed. Engaging these abject objects, I wanted to reinvigorate the stories that they told, to revisit them on my own terms rather than coming to them as consumable, commodified images. In my appropriation of these images and material, I wanted to reposition the context under which these histories were situated, contextualized, and framed. In this context, I wanted to own that history - I wanted to/needed to have them.

III.

THE second part of a large-scale, multi-year project, *Focusing (Vol II)* was a solo exhibition held at Corner gallery in Avondale, Chicago in October 2016. An excerpt in a larger work that recontextualized material objects, images, and ephemera from the era of U.S. colonialism in the Philippines, this work primarily highlighted the re-establishment of military marching bands as a strategy for sustained control. This work focused on the presence of U.S. colonial power through the technology of control of Filipino breath, specifically exhalation. While the establishment of military marching bands preceded U.S. colonial rule, the particular intervention of U.S.-led military operations sought to use the bands as strategies within the broader narrative of "benevolent assimilation" to "civilize" the "savage." In Mary Talusan's discussion of Filipino music scholar Hilarion F. Rubio, she notes that "to Rubio, American tutelage transformed Filipino bands into orderly disciplined entities, embracing

the traits of modernity and moving towards 'progress'." This "progress" that Rubio spoke of was a colonial project to essentially refashion Filipinos into a racist white imaginary. In the book *Benevolent Assimilation*, Howard Taft was quoted as saying "'our little brown brothers' would need 'fifty or one hundred years' of close supervision 'to develop anything resembling Anglo-Saxon political principles and skills.'" Through the use of the camera to capture and reprint images that constructed the "success" of the colonial project, the image of the marching band would only further inscribe the legitimacy and justification for its continuation.

In 1904, an African American conductor by the name of Walter Howard Loving brought his 80-plus-piece marching band known as the Philippine Constabulary Band (PCB) to the St. Louis World's Fair. A projected space of the future, the World's Fair not only showcased the discoveries of the era, but touted the necessity for colonial presence within the Tropics as the PCB signified the attempt of a "civilized savage." As controlled "savages", the PCB thus instantiated a way for a US imperial logic to be employed, replicated, and sought. Taken metaphorically, this usurpation of control disabled Filipinos the ability to speak as their exhalations were entirely at the mercy of their instruments. A mechanism for rupturing the ability to speak, the PCB thus functioned as an oppressive, disastrous situation that stunted Filipinos from the possibility of remaking their subjectivity.

Without the ability to speak, their/our sensibility of agency had to be recalibrated. We had to trouble how agency was constructed. We had to reclaim the breath. Our ability to endure is contingent on our ability to breathe.

WORKS CITED

Balce, Nerissa. *Body Parts of Empire: Visual Abjection, Filipino Images, and the American Archive*. Ann Arbor, MI: University of Michigan Press, 2016.

Choy, Catherine Ceniza. "Salvaging the Savage: On Representing Filipinos and Remembering American Empire." In *Screeming Monkeys: Critiques of Asian American Images*, edited by M. Evelina Galang, 35–50. Minneapolis: Coffee House Press, 2003.

Miller, Stuart Creighton. *Benevolent Assimilation: The American Conquest of the Philippines, 1899-1903*. New Haven, CT: Yale University Press, 1982.

See, Sarita Echavez. *The Decolonized Eye: Filipino American Art and Performance*. Minneapolis: University of Minnesota Press, 2009.

Talusan, Mary. "Music, Race, and Imperialism: The Philippine Constabulary Band at the 1904 St. Louis World's Fair." *Philippine Studies* 52, no. 4, World's Fair 1904 (2004): 499–526.

BOOK REVIEW

Benjamin L. Locke, University of Illinois at Chicago

Bone Rooms: From Scientific Racism to Human Prehistory in Museums. By Samuel J. Redman. Harvard University Press, 2016. 373 pages. $21.62.

THOUSANDS of individual remains, spanning centuries and continents, sit idly, stored in museums across the United States. What strange final resting places these rooms must be, where deceased individuals are not known by their name, but only by their catalogue number and provenance. The massive collections of human skeletal remains found in institutions such as the Smithsonian, the Field Museum, and the Mütter Museum are a result of the pervasive bone collecting of anthropologists and museums following the Civil War up until the middle of the 20th century. Racial classification theory was gathering steam, by scholars, academic institutions, and the general public during the 20th century. Anthropologists such as Aleš Hrdlička of the Smithsonian Institute set out to amass the most impressive collections of human skeletal remains ever imagined. Race became an obsession for scientists, and many were determined to find conclusions that aligned with the sociocultural power dynamics of the time.

 Bone Rooms: From Scientific Racism to Human Prehistory in Museums, by Samuel J. Redman, tells the story of how human skeletons became so highly sought after by scientists, academic institutions, and museums. The proliferation of bone rooms resulted in a number of museums becoming massive storage facilities for human remains. Redman dives into the ethical and moral quandaries of museums and scholars gathering bodies for science while showing the intellectual trajectories surrounding racial theory, human prehistory, and human evolution during the first half of the 20th century.

Redman is an assistant professor of history at the University of Massachusetts Amherst, specializing in 19th and 20th century U.S. history. His doctoral dissertation, "Human Remains and the Construction of Race and History, 1897-1945" was completed in 2012 at the University of California, Berkeley and printed by Harvard University Press. Redman successfully provides readers with a dense trove of information while maintaining a level of readability that is delightful and a breath of fresh air considering the esoteric nature of the subject matter.

Redman shapes his research in a semi-chronological fashion. The first two chapters, "Collecting Bodies for Science," and "Salvaging Race and Remains," introduce the reader to the origins of bone collecting and the various ways in which skeletons found their way into museum bone rooms. These chapters also explain how public and academic interest in racial classification shaped the way that human skeletal remains were collected, studied, and interpreted. The chapters that follow, "The Medical Body on Display," and "The Story of Man through the Ages," provide case studies that support Redman's research. These chapters explore the history of one of the most influential medical museums in the United States, The Mütter Museum in Philadelphia, as well as the beginnings of the San Diego Museum of Man, which was borne from the largest exhibition on race and human prehistory, featured at the Panama-California Exposition in 1915. The final two chapters, "Scientific Racism and Museum Remains," and "Skeletons and Human Prehistory," show the ever changing paradigms surrounding racial classification theory and anthropology's subsequent shift to focusing on human prehistory and cultural relativism.

Rather than insert himself into the debate regarding the ethical dilemmas and politics of collecting and keeping human skeletal remains in museums, Redman strives to put forth a detailed history and context surrounding the proliferation of bone rooms during the early 20th century. Redman acknowledges the scope of his topic, writing, "Making the case for the cultural significance of these bone rooms is easier than gauging their exact size." The objective of *Bone Rooms* is to tell the stories behind those responsible for the pervasive and unprecedented process of amassing the remains of the dead for research and public display. Most importantly, *Bone Rooms* successfully holds these individuals and institutions accountable for their actions.

For a book so meticulously researched and thoroughly detailed, the difficulty of choosing key topics to focus on is palpable. I have chosen, for the purposes of this review, to focus on three of the strongest narratives found in Redman's *Bone Rooms*. First, I find Redman's beginning two chapters to be particularly strong in detailing how common and exploitive bone collecting (especially for purposes of racial classification) was at this time in American history. The following excerpt from the first chapter sums up this claim:

> While human remains arrived at museums through professionalizing channels in archaeology and physical anthropology, museums also began acquiring skeletons from other diverse and enigmatic sources. Medical officers, amateur collectors, looters, pothunters, and treasure hunters worked over many of the same sites later studied by professional archaeologists and anthropologists (2016, pg 65).

With the combined interest of the general public, scholars, and research institutions, museum bone rooms filled at an exponential rate. The lax or non-existent regulations surrounding human skeletal remains aided in this process as well. Redman expertly details the beginnings of bone collecting, from the Army Medical Museum's display of a Dakota man's remains found in 1864, to the unparalleled collection of human bones amassed by Aleš Hrdlička and the Smithsonian Institute by the middle of the 20th century. The strength of the first two chapters is buttressed by a flowing narrative that leads readers on a logical and meaningful path to understanding how commonplace it was for researchers and institutions to gather human remains, and their willingness to do so by any means necessary.

Several famous anthropologists such as Franz Boas, W. Montague Cobb, and Alfred Kroeber make appearances throughout Redman's work. However, the enigmatic and obsessive anthropologist, Aleš Hrdlička, is the star of the show. Redman makes note that bone collecting was quite commonplace amongst anthropologists of all types, however, no anthropologist collected and researched human skeletal remains at the rate and scale of Aleš Hrdlička. Hrdlička's obsessive research brought

his pseudoscientific theories surrounding race into mainstream thought as he took center stage in the burgeoning field of physical anthropology during the early 20th century. Despite racial classification theory waxing and then waning amongst anthropologists at the time, Hrdlička was determined to collect bones and further his theories on race and human prehistory.

The story of Aleš Hrdlička's intellectual aspirations and achievements appear throughout *Bone Rooms*. At every step of the journey, Hrdlička's influence is a part of the discussion one way or another. His rivalry with the more progressive Franz Boas regarding the concept of race also creates a dynamic that is so welcome in an academic text. In some ways, Hrdlička functions as the villain stuck in the past as his contemporaries began to reject the concepts of racial classification, stratification, determinism. Ironically, the near-universal acceptance of eugenics, comparative anatomy, and other forms of racially charged pseudo-science was essentially undone by Hrdlička and other like-minded anthropologist's own findings. The quantity of skeletal specimens and data subsequently brought up more questions and contradictions within racial classification theory, leading to its unraveling and categorical rejection. Aleš Hrdlička's place in the history of the museum bone rooms serves as a narrative adhesive that is both informative and fascinating. Hrdlička is the tie that binds everything together, providing continuity and humanity to Redman's comprehensive work.

The third notable strength I found in *Bone Rooms* was Redman's epilogue, which connected the comprehensive amount of information provided together into a meaningful, contemporary context regarding the ethical debates surrounding Museums that store and exhibit human skeletal remains. Most notably, he remarks how the race amongst researchers and museums to amass the best collections for their bone rooms allowed one concept to pass by everyone involved in this process: the humanity behind the deceased who make up these massive collections. Redman's concluding thoughts on the history of museum bone rooms allows the information from the book to expand and become a part of the discussion regarding the legacies surrounding these collections and the scholars who created them. Redman makes note of a sobering fact early on: "Recent estimates have placed the number

of Native American remains in U.S. museums at about 500,000" (2016, pg 15). This jarring number demonstrates that the work to undo the wrongdoing behind collecting the remains of the deceased for science is far from over. Redman writes in his final paragraph, "If these now hushed voices could speak directly to the living, perhaps they would simply be intent on reminding us of their existence. They might try to humanize themselves against their portrayal as numbered scientific specimens" (2016, pg 290).

The comprehensive and thorough nature of *Bone Rooms* serves as one of its primary strengths. Sometimes certain information from a different section of the book would be unnecessarily revisited or reiterated, but this is only a minor criticism. It is also worth noting that *Bone Rooms* does not follow a perfectly linear, chronological trajectory. This does not take away from the book as much as it went against my own expectation of how the book would progress as I read on. Despite a few minor criticisms, *Bone Rooms* ultimately succeeded at what it set out to do, and will more than likely serve as a vital book for anthropologists and historians for years to come.

Future cultural workers involved in museums will undoubtedly have to wrestle with the problematic legacy of bone collections. The origins of these collections are truly insidious. Scientific racism unethically brought these deceased individuals from their original resting places for purposes that were futile and inextricably linked to systemic racism. The task of repatriating and creating a narrative that acknowledges the wrongdoing of our academic forebears is the first step in a very long journey towards justice. Redman's *Bone Rooms* is necessary reading for scholars interested in the history of anthropology and the ethical representation of cultures and individuals in museums, and can be a springboard for further research and discussion on these topics.

WORKS CITED

Redman, Samuel J. *Bone Rooms: From Scientific Racism to Human Prehistory in Museums*. Cambridge, MA: Harvard University Press, 2016.

CONFRONTING THE HOLOCAUST
IMMERSIVE COUNTER-MEMORIALS AS SITES OF COLLECTIVE MEMORY
Lillian Hussong

"When it begins to come to life, to grow, shrink, or change form, the monument may become threatening. No longer at the mercy of the viewer's will, it seems to have a will of its own, to beckon us at inopportune moments." – James Young[1]

ART serves as a deeply reflective vessel of memory for the era in which it is produced. Early twentieth century art such as Expressionism, Cubism, Grotesque, and Dada reflected the turbulence and chaos of the post-World War I era. Contrary to earlier eras in which art often characterized heroic, Romantic, and aesthetically "proper" subjects, twentieth century art often sought to grapple with the emotional responses caused by a systemically altered world.[2] While art may express an *instance* of memory, monuments and museums function similarly as *sites* of memory. The traditional narrative of monuments and museums as sites that explain the past were uprooted by the unprecedented magnitude of World War II and the Holocaust.[3] How could one succinctly explain the systematic extermination of 11 – 17 million people with a traditional "plaque and statue" in a museum?

Artists in the latter half of the twentieth century sought to confront the horrors of the Holocaust with a new form of art known as a counter-memorial. Counter-memorials challenged the viewer to look

1. James E. Young, *The Texture of Memory: Holocaust Memorials and Meaning* (New Haven, CT: Yale University Press, 1993), 37.
2. Alan E. Steinweis, "The Nazi Purge of German Artistic and Cultural Life," in *Social Outsiders in Nazi Germany*, eds Robert Gellately and Nathan Stoltzfus (Princeton University Press, 2001), 99-101.
3. Cecily Harris, "German Memory of the Holocaust: The Emergence of Counter-Memorials," *Penn History Review* 17, no. 2 (Spring 2010), 43-45.

introspectively and retrospectively in that they delved deeper into the question of what they came to represent. Unlike the traditional monument that tells the onlooker what happened, a counter-memorial questions *us*, challenging us to look inward and find the answers.[4]

This paper argues that museums may also act as counter-memorials in addition to standalone sites. First, it begins with a brief historical explanation of what counter-memorials are and how they exist as sites of memory. Second, it examines a specific type of counter-memorial—what, in my experiences, I have come to call an "immersive counter-memorial"—in which visitors are able to walk around or become totally immersed in the work. Finally, I use two interconnected sites of memory as evidence to establish my argument: "The Garden of Exile" within the *Jüdisches Museum Berlin* (Jewish Museum Berlin), and the Jewish Museum Berlin itself as an immersive counter-memorial.

COUNTER-MEMORIALS

THERE was not yet a name for the unprecedented events of the 1930s and 1940s in which 11 – 17 million people were systematically exterminated by the National Socialist German Workers' Party (NSDAP, hereafter referred to as the Nazi Party).[5] Reeling from their past, Europeans were confronted with the question: "How do we remember?" How can collective memory be constructed with the voices of perpetrators, bystanders, and victims? Given Germany's historical penchant for monument construction, traditional commemoration seemed grossly insignificant in the face of systematic, manufactured extermination.[6]

As the trauma of the "first generation" of Holocaust survivors was transmitted to their children, "second generation" Germans and Austrians found themselves indirectly situated within the post-Holocaust historical narrative while simultaneously trying to distance themselves from it. The idea of memorializing a period of history of inconceivable guilt and atrocity proved difficult: artists therefore sought to create

4. Harris, "German Memory of the Holocaust: The Emergence of Counter-Memorials," 35-36.
5. Yehuda Bauer, *A History of the Holocaust* (Danbury, CT: Franklin Watts, 2001), 89.
6. Harris, "German Memory of the Holocaust: The Emergence of Counter-Memorials," 37.

a physical representation of the collective guilt felt in Germany and Austria. James Young, author of *The Texture of Memory*, explained the conundrum surrounding collective memory and sensitivity: "Instead of searing memory into public consciousness, they fear, conventional memorials seal memory off from awareness altogether."[7]

The rise of counter-memorials as a way to challenge the conventional construction of collective memory therefore "...frankly acknowledge[s] the impossible but necessary task that they undertake, that of representing the unrepresentable, and they embody this acknowledgement in their challenge to every aspect of traditional monument culture."[8] Such counter-memorials exist throughout much of Europe and tend to be in urban areas either to specifically attract attention or to deliberately fade into the subconscious. For example, German artist Gunter Demnig (b. 1947), is known for his 25,000 unassuming *stolperstein* (stumbling stone) memorials in Germany, the Netherlands, Poland, Austria, the Czech Republic, Ukraine, and Hungary. The *stolperstein* project began in 1993 when Demnig created small brass tiles as epitaphs to murdered Jews. Each tile indicated a victim's name, their birthdate, country of origin, date of death, and if possible, the location of death. Demnig then traveled to the victim's city and dug out a few cobblestones on the street outside of their former residence, and replaced the uprooted stones with the *stolperstein*.[9]

In a symbolic way, Demnig uprooted stones that had always existed, and returned them to the ground with the painful addition of tombstone-like tiles beside it. In this subtle form of memorialization, pedestrians could easily walk over the tiles, unaware that they were walking over a counter-memorial, or they might take notice and read the information inscribed on the tile. The *stolperstein* gives no more information about the project, the artist, or the intent—the pedestrian must find the answer themselves if they so choose.

7.　Young, *The Texture of Memory*, 28.

8.　Harris, "German Memory of the Holocaust: The Emergence of Counter-Memorials," 35.

9.　Thorsten Halling, "'Plötzlich und für uns alle unfassbar...' Der vorzeitige Tod zwischen privater und öffentlicher Erinnerung seit dem Zeitalter der Aufklärung," *Historische Sozialforschung* 34, no. 4 (2009), 233.

Counter-memorials can also be more noticeable, and thus noticeably more controversial. In Vienna, Austria, lies a monument at the *Albertinaplatz* called *A Monument against War and Fascism* erected in 1988 by Alfred Hrdlicka (1928 – 2009). The counter-memorial contains five works: "the Gate of Violence," consisting of two massive stones quarried from Mauthausen, a sculpture of "the Street-Washing Jew," indiscernible as a human being from far away, a pillar called "Orpheus Entering Hades," and lastly, a thirty-foot high pillar with fragments of Austria's constitution inscribed into it. Together, these pieces generated a firestorm of controversy and remains a controversial counter-memorial to the present day. Hrdlicka received criticism for his depiction of a Jewish man on his hands and knees, humiliated by the Viennese (and Austrian) indifference to his plight and the plight of all Jews.[10] The sculpture, facing the direction of "Orpheus Entering Hades," which faces the fragmented pillar of the Austrian constitution, can be interpreted as the forced submission of the Jews to the Nazi regime.

Such counter-memorials beckon passersby to examine the various elements of their composition. Why are these pieces of art here? For what reason are the pieces positioned in a line? What is the obscure object of the person doing? There are no textual answers to this memorial, impelling the onlooker to ask more questions to find an answer. The *Monument against War and Fascism* is permanent—for as long as Austrians and tourists alike pass by the *Albertinaplatz*, the sculptures will continue to be transparent, unavoidable by Austrian history and collective memory in the post-Holocaust era.

IMMERSIVE COUNTER-MEMORIALS

AFTER the conclusion of Stockton University's biennial Holocaust study tour in 2012, where we studied collective memory and memorialization in Germany and Poland, I realized that the term "counter-memorial" could not fully describe large-scale Holocaust memorials that exist in Germany, such as the *Denkmal für die ermordeten Juden Europas* ("Memorial to the Murdered Jews of Europe"), the architectural style of the *Jüdisches Museum Berlin* (Jewish Museum Berlin), and *Der Garten des*

10. Young, *The Texture of Memory*, 106-112.

Exils ("The Garden of Exile") found inside the Jewish Museum Berlin. Unlike the Demnig and Hrdlicka memorials, immersive counter-memorials are massive works of art that beckon the viewer within its confines, providing the visitor with a "three-dimensional experience." Although these memorials are effective when viewed from afar, the idea of contemplation is more so contingent upon the viewer's participation within the memorial's depths. Here, I use both the Jewish Museum Berlin and its exhibit "The Garden of Exile" as two examples of immersive contemplation.

JEWISH MUSEUM BERLIN / GARDEN OF EXILE

THE Jewish Museum Berlin is not a Holocaust museum, but the Holocaust "is inevitably built into it."[11] Constructed in 1998, architect Daniel Libeskind (b. 1946) built a new museum around the historic 1735 Superior Court of Justice building for the Margraviate of Brandenburg, known as the *Kollegienhaus* (Old Building).[12] The juxtaposition of the iconic baroque building with Libeskind's post-modern zinc-clad construction is a specific memory itself, symbolic of the denigration of Jewish life in Germany. Tom Freudenheim, the museum's first director, explained that "[w]e are not starting out with objects, we're starting out with a story… it goes back to Jews coming into the Roman settlements and extends all the way to the present."[13]

Jews who migrated to modern-day Germany played as much of a role in the creation of German culture and history as did other groups.[14] For this reason, Libeskind wanted to literally build an extension out of the Old Building, to represent that the two buildings shared a connection: Jews were present and participants in the days of the Old Building's activity, and they were also forced out of the city after the rise of antisemitism in the nineteenth century.[15] The New Building is distinctly

11. Tom Freudenheim, "Berlin's New Jewish Museum: An Interview with Tom Freudenheim," *PAJ: A Journal of Performance and Art 22*, no. 2 (May 2000), 46.
12. " Der barocke Altbau," Jüdisches Museum Berlin, https://www.jmberlin.de/der-barocke-altbau.
13. Freudenheim, "Berlin's New Jewish Museum," 40.
14. Ronnie S. Landau, *The Nazi Holocaust* (Chicago, Ivan R. Dee, 2006), 48-54.
15. Michael Burleigh and Wolfgang Wipperman, *The Racial State: Germany 1933 – 1945* (Cambridge University Press, 1991), 36-37.

different from the Old Building as evidenced by the malleable appearance of the zinc. The Jews of Germany were part of Germany's edifice, but were hammered and beaten throughout time. They remain today, but their memory is delicate, just as the building appears.

The very nature of the building as a counter-memorial challenges the visitor in a number of ways. Visitors have no choice but to descend from the Old Building down a flight of steps into the New Building to begin the tour. Once underground, there are no signs pointing to where one should begin their tour. Visitors must rely on their intuition to begin the tour, eventually realizing that this reliance on intuition is a deliberate theme of the museum. The floor plan of the New Building includes three axes, unbeknownst to the visitor, as one can only ever see two axes at a time. The longest axis is the Axis of Continuity, intersected by the Axis of Exile and the Axis of the Holocaust. The intersection of these three themes is indicative of Jewish continuity throughout German history: that Jews have always lived in Germany, that they were forced to leave, and that they were ultimately systematically murdered for their mere existence.[16] These axes contain few exhibition items as the intent for the floor plan is immersive—it is itself a counter-memorial where one learns more directly about the plight of the Jews from being immersed in the memorial rather than being told what to think.

There is only one entrance and exit point to The Garden of Exile, found in the Axis of Exile, indicative of the ambiguous and yet overt nature of National Socialism's intent to rid Germany of its Jewish population. In Libeskind's own words, The Garden of Exile attempts "to completely disorient the visitor. It represents a shipwreck of history."[17] Forty-nine stelae (upright stones) are erected on a square garden with a twelve-degree gradient. The visitor enters the garden on the downward end of the gradient, and must trudge up the rickety cobblestone path among the stelae to get to the opposite end. Above, branches covering the stelae block some sunlight, casting shadows along the stelae, significant of the uprooting of Jewish life.[18] The outside exhibit is cut off from

16. "Der Libeskind-Bau." Jüdisches Museum Berlin. http://www.jmberlin.de/main/DE/04-Rund-ums-Museum/01-Architektur/01-libeskind- Bau.php.

17. "Der barocke Altbau." Jüdisches Museum Berlin.

18. Nili Keren, "Holocaust Memory in Germany," (lecture, Stockton University, Galloway, NJ, October 25, 2012).

the outside world by a hedgerow that encases the exhibit, indicative that exile away from Germany did not signify freedom.[19] As visitors end their tour of the exhibit, they must return underground into the Axis of Exile, eventually walking again down the Axis of Continuity and passing the Axis of the Holocaust.[20]

To visit the Jewish Museum Berlin is a profound experience. The Garden of Exile is a prime example of how immersive-counter memorials go one step beyond an already provocative narrative by challenging visitors to put themselves in the shoes of those who lived in Berlin decades ago. Putting the idea of exile into context, the heavy ascent up the steep gradient, the stelae blocking one's peripheral view, the branches covering overhead, all suggest to an extent the fear and confusion the Jews felt during National Socialism's ascent to power. In the exhibit, one can simulate the fear of turning at each corner, not knowing if someone will block the path or if the aisle is clear. It conveys a reversion to one's senses, that only instincts can guide a person through the quagmire of German instability.

This reversion to basic human instinct is the ultimate achievement of the immersive counter-memorial as both a stand-alone work and as the embodiment of a museum. Not only do such sites of memory turn the question of what happened during the Holocaust back to the participant, but it also transports the visitor to a time when feelings of fear and wariness persisted amongst Jews in Europe. We must ask ourselves what led to such a slippery slope for our Jewish neighbors and friends just as the Garden of Exile and the Jewish Museum Berlin literally appear to convey. It is a work that penetrates both the conscious and the subconscious, leaving the visitor with no answers but more questions.

The phrase "never again" was used to describe the atrocities of the Holocaust and their painful mark on history. Unfortunately, humanity looked on as several more genocides after the Holocaust were committed, proving that some questions could never be answered. Traditional monuments will tell the viewer what happened, affecting the conscious stream of thought. Counter-memorials will ask *"why,"* penetrating deeper into the subconscious. Immersive counter-memorials, however,

19. "Daniel Libeskind Jewish Museum 2," Youtube, video file, http://www.youtube.com/watch?v=_OYlkSukgKl.
20. Keren, "Holocaust Memory in Germany."

will target both, calling upon experiences of memory from oneself and from the individuals the memorial seeks to commemorate.

Famed scholar Maurice Halbwachs (1877 – 1945) published *On Collective Memory* eight years before the Nazi Party's rise to power, though he died in Buchenwald concentration camp in 1945. His work seemed to ironically anticipate the coming political upheaval:

> Just by thinking about it we believe that we can recall the mental state in which we found ourselves at that time... In reality we would feel incapable of mentally reproducing all the events in their detail... because we feel what a gap continues to exist between the vague recollection of today and the impression of our childhood which we know was vivid, precise, and strong.[21]

Halbwach's thoughts echo throughout the constructs of immersive counter-memorials; visitors to sites of Holocaust collective memory remain aware that the historical gap between the contemporary and the past cannot be bridged, while reflecting on the totality of persecution in Europe in the 1930s and 1940s. Just like the Jewish Museum Berlin, the Garden of Exile does not overtly represent the Holocaust, but the theme of the Holocaust "is built into it."[22] It is, as with all counter-memorials, up to the visitors to search for the meaning and answers themselves.

21. Maurice Halbwachs, *On Collective Memory* (Chicago: The University of Chicago Press, 1992), 46.
22. Freudenheim, "Berlin's New Jewish Museum: An Interview with Tom Freudenheim," 46.

BIBLIOGRAPHY

Bauer, Yehuda. *A History of the Holocaust*. Danbury, CT: Franklin Watts, 2001.

Burleigh, Michael and Wolfgang Wipperman. *The Racial State: Germany 1933 – 1945*. Cambridge University Press, 1991.

"Daniel Libeskind Jewish Musuem 2." Youtube. Video file. http://www.youtube.com/watch?v=_OYlkSukgKl.

Freudenheim, Tom. "Berlin's New Jewish Museum: An Interview with Tom Freudenheim." *PAJ: A Journal of Performance and Art 22*, no. 2 (May 2000): 39-47.

Gellately, Robert and Nathan Stoltzfus, eds. *Social Outsiders in Nazi Germany*. Princeton University Press, 2001.

Halbwachs, Maurice. *On Collective Memory*. Chicago: The University of Chicago Press, 1992.

Halling, Thorsten. "'Plötzlich und für uns alle unfassbar...' Der vorzeitige Tod zwischen privater und öffentlicher Erinnerung seit dem Zeitalter der Aufklärung." *Historische Sozialforschung 34*, no. 4 (2009): 231-46.

Harris, Cecily. "German Memory of the Holocaust: The Emergence of Counter-Memorials." *Penn History Review* 17, no. 2 (Spring 2010): 34-59.

Keren, Nili. "Holocaust Memory in Germany." Lecture. Stockton University. Galloway, NJ. October 25, 2012.

Landau, Ronnie S. *The Nazi Holocaust*. Chicago: Ivan R. Dee, 2006.

Steinweis, Alan E. "The Nazi Purge of German Artistic and Cultural Life."
 In *Social Outsiders in Nazi Germany*. Eds. Robert Gellately and Nathan
 Stoltzfus. Princeton University Press, 2001.

Stiftung Jüdisches Museum Berlin. "Der barocke Altbau." Jüdisches Mu-
 seum Berlin. https://www.jmberlin.de/der-barocke-altbau.

Stiftung Jüdisches Museum Berlin. "Der Libeskind-Bau." Jüdisches Mu-
 seum Berlin. https://www.jmberlin.de/der-libeskind-bau.

Young, James E. *At Memory's Edge: After-Images of the Holocaust in
 Contemporary Art and Architecture*. New Haven, CT: Yale University
 Press, 1993.

Young, James E. *The Texture of Memory: Holocaust Memorials and
 Meaning*. New Haven, CT: Yale University Press, 1993.

THE WHITE PALACE OF THE WEST
Jonathan Kelley

I.

PART of me wants to buy a handcuff key chain. The older I get, the more I appreciate mementos. They help me unjumble my past.

II.

IT's late October 2016. The museum usually isn't open this late in the year. But a sign on the gate says to call if you want to visit. I call, and 15 minutes later, Don, the museum president and *de facto* director, is giving us a guided tour.

First up, the introductory video: a 10-minute documentary called "Landmark in Stone: The White Palace of the West"—set to ragtime music. The video explains that the Iowa State Penitentiary was built in Anamosa in 1873 by the prisoners themselves, near a quarry. It was considered among the most modern and secure prisons in the country. It's still there, looking more like a castle than a palace; quite magnificent, really.

A few feet away from the north wall sits a small outbuilding, which used to serve as the prison's cheese factory. The prisoners made and sold cheese. We're sitting in that building, which is now the Anamosa Penitentiary Museum.

The narrator explains that back in the day, interested parties could pay twenty-five cents for a prison tour. Now you have to settle for the museum. Now it's three dollars.

III.

WE haven't come all the way to Anamosa for this tiny museum. This is a detour before our main mission: two days of canvassing for Hillary Clinton in nearby Waterloo.

Waterloo is a solid, Midwestern, working class town. Unions are strong. It's far more diverse than most of Iowa. While canvassing, my boyfriend, our two friends, and I meet recently naturalized citizens from Mexico, a multigenerational African-American family from Chicago, a refugee from Burma, and a small business owner from Jamaica. It is nonetheless majority-white. Clinton will win Waterloo and Black Hawk County.

IV.

THE population of the Iowa State Penitentiary is also more diverse than most of Iowa. It is nonetheless majority-white. Clinton will lose Anamosa and Jones County.

V.

THE inmates won't be allowed to vote.

VI.

IN a 2015 book on penal tourism, criminologist Michael Welch writes, "Prison museums have enormous cultural pull due to the themes of evil, murder, and execution."[1] Welch's analytical frame is Tony Bennett's Foucauldian observation that both museums and prisons are part of an "exhibitionary complex"; both developed to help advance the ability of the state to control and incorporate its subjects via the power to "show and tell."[2] Welch writes at length on the importance of prison museums' "sitedness" (in former prisons, mostly overseas) as helping to reify the authority of the narratives put forth by both institutions. In what's known as the "museum effect," visitors absorb a museum's narratives via artifacts, text, photographs, illustrations, tours, and other aspects of authoritative history and truth.

Anamosa is adjacent to a *functioning* prison. So are prison museums I visited in Louisiana and Colorado. A prison museum in Michigan is *inside* a functioning prison.

1. Michael Welch, *Escape to Prison: Penal Tourism and the Pull of Punishment* (Oakland: University of California Press, 2015), 23.
2. Michael Welch, *Escape to Prison: Penal Tourism and the Pull of Punishment* (Oakland: University of California Press, 2015), 7.

VII.

DID I mention the USA has an issue with mass incarceration?

VIII.

WELCH'S museums are all considered meaningful cultural heritage sites. Some are explicitly sites of conscience, in that they tell stories of past colonial (in the case of Seoul and Hong Kong) or dictatorial (South Africa) regimes' human rights violations, centering prisoner-as-victim narratives. Unlike most American prison museums, Eastern State Penitentiary explicitly asks visitors to question the logics of mass incarceration.

IX.

EASTERN State Penitentiary—the actual prison—closed in 1971.

X.

MANY factors determine whose narratives a given museum centers. Anamosa has a population of 5,500. The prison is the main employer. The driving force in opening the museum was a psychologist who worked at the prison for decades. Don himself is a retired prison staff member, having begun work there in 1961. Anamosa tells its stories primarily through the voice of the prison workers, primarily to people who have never and will never spend time in a state prison.

But they aren't unkind narratives. Yes, there's a morbid focus on methods of surveillance and restraint; on implements of execution. And there's the obligatory **FAMOUS INMATES** section (John Wayne Gacy is the star in Anamosa; Bonnie and Clyde served that purpose in Texas).

But you can tell—the former employees feel a real kinship with the prisoners. Don plays up the humane features of the prison. The tennis court. The Native American sweat lodge. The hospice.

XI.

THE gift shop is the first and last thing you encounter at the Iowa State Penitentiary Museum. It features T-shirts (inmates in various uniforms with the caption "HARD TIME"), pens, magnets, those handcuff keychains I mentioned, bracelets with guard whistles, and a small selection

of historical books about the prison and the area. There's also a jigsaw puzzle for sale, featuring a photo of the prison; a sample on a folding table had been left mostly complete. As my boyfriend and two friends complete it, I finish my talk with Don.

I'm not a tourist. I am a student. I'm not a museum-goer. I am a museum studier. I'm not being given a guided tour. I am interviewing Don. For a paper. Scholarship.

At Don's gentle urging, I do put on a prisoner costume, stand behind the cell bars, and have Don take a picture of me. My smiling visage is ghoulish. I don't intend it to be.

XII.

WHEN we planned the trip, we thought Iowa would be a swing state. A lot of people did. We remain upbeat and optimistic through the weekend.

But Clinton will end up losing the state by nearly 10 points.

XIII.

I'M not over it.

XIV.

MUSEUMS are political entities but they can't be partisan entities. I don't know quite how to reconcile that.

XV.

I end up buying those mini handcuffs after all. I haven't yet put them on my keychain.

BIBLIOGRAPHY

Bennett, Tony. "The Exhibitionary Complex." *New Formations* 4 (Spring 1988): 73–102.

Welch, Michael. *Escape to Prison: Penal Tourism and the Pull of Punishment*. Oakland: University of California Press, 2015.

ABOUT THE CONTRIBUTORS

JAVAIRIA SHAHID
Language Matters

JAVAIRIA Shahid (PhD candidate, University of Illinois in Chicago, Art History) is an architect and historian based between Chicago and Islamabad. She has a graduate degree in architectural history and theory from the Graduate School of Architecture, Planning and Preservation, Columbia University. Graduating with gold medals from her undergraduate institution in Pakistan, Shahid has been the recipient of the Fulbright Scholarship, the Humanities Without Walls grant, in addition to numerous research awards. Her research considers the relationship between development and the environment in South Asia, with particular regard to epistemological disjunction of two entangled projects: the present-day production of global heritage, and the historic-colonial-Modernist "other"ing of nature and ecology.

FLOATING MUSEUM
Welcome

FLOATING Museum is a collaborative art project that creates temporary, site-responsive museum spaces to activate sites of cultural potential throughout Chicago's neighborhoods. Our interactive spaces engage local artists, historians, and organizations in events that challenge traditional museum thinking and generate community engagement and conversation.

SARITA HERNÁNDEZ
Introduction

SARITA is a XicanaDyke artivista, arts educator, and oral hxstorian from southeast Los Angeles County. Sarita is a grad student at University of Illinois, Chicago in the Museum and Exhibition Studies and served as the publication coordinator for *Fwd: Museums* for its first two years.

GEORGINA VALVERDE
The Society of Smallness; A Brief History

GEORGINA Valverde is an interdisciplinary artist and educator whose work encompasses sculpture, performance, writing, and critical peda-gogy. She holds an MFA from the University of Illinois at Chicago and a BFA in Painting and Printmaking and BA in Modern Languages from James Madison University, Virginia. Valverde is the founder and director of the Society of Smallness and Documents Bureau, two participatory projects that invite us to re-examine our relationship with each other and the world.

ELIZABETH LALLEY
Life in Miniature: An Ode to the Thorne Rooms

ELIZABETH Lalley is a curator, writer, and researcher, currently pursuing an MA in Museum & Exhibition Studies at the University of Illinois-Chica-go. She graduated from the University of Michigan with a BA in English Literature and Creative Writing.

YASMIN ZACARIA MITCHEL
Fresh Theft: Consuming Art

YASMIN Zacaria Mitchel is a current DePaul University student, pursu-ing a BFA in Dramaturgy/Criticism with minors in History and Museum Studies. She freelances with various Chicago nonprofits and organiza-tions, and has been trained in various fields such as archiving, exhibit design, audience engagement, and curation. Her favorite projects draw

from storytelling and filling in historical gaps, for example "Forty Blocks: The East Garfield Park Oral History Project", her most recent work with Chicago History Museum.

JANE DARCOVICH
Small Things with Great Love: An Art Department - Library Exhibition Initiative

JANE Darcovich is the Liaison Librarian for Architecture and Art at the University of Illinois at Chicago's Richard J. Daley Library, where she provides classroom research instruction, individual consultations, and collection development services. She is based in the library's Digital Programs and Services Department and assists with developing the library's digital image collections.

NOORA AL BALUSHI
A Conversation By The Loo on Small Artist-Run Spaces

NOORA Al Balushi is from the capital city of the Sultanate of Oman, Muscat, a multi-cultural coastal town resulting from centuries of encounters with various civilizations. She is currently pursuing a Masters in Museum and Exhibition Studies at the University of Illinois at Chicago, her interests in museums stem from the encounter between western cultural practices being implemented in an eastern context, affecting how such practices are received, perceived, and implemented. She is also interested in the concept of identity, whether cultural or national, as it forms the platform for cultural discourse in the Gulf.

JUAN CAMILO GUZMÁN
Lift to Release

JUAN Camilo Guzmán is interested in shopping. He chooses images from mass culture to talk about politics, art, painting, cultural issues, taste, the material world, pleasure, power, sexuality, gender and the role of the artist's external life in the larger culture. He is also able to make jokes without smiling. Juan Camilo was born in Bogotá, Colombia where he lived until 2014. He received his MFA in Painting and Drawing from SAIC.

ALETHEIA WITTMAN
Expanding Care: Curation in the Age of Engagement

ALETHEIA Wittman cofounded and coordinates The Incluseum, a project and blog that advances new ways of being a museum through critical discourse, community building and collaborative practice related to inclusion in museums. She is a museum consultant and teaches with the University of Washington Museology Program.

SILVIA INÉS GONZALEZ
Panoptican't | Structures of Power

SILVIA Gonzalez is an Artist and Educator living in Chicago creating zines and curating workshops to address violence, imagination, play, freedom, and confinement. Collaborative educational and artistic projects include work with groups such as the Chicago ACT (Artist Creating Transformation) collective and the 96 Acres Project, led by the Artist Maria Gaspar. Silvia Gonzalez has experience organizing workshops that centralize creative work with intergenerational participants interested in critically disrupting current power imbalances. Her writing and performance work references justice work, trauma, healing, history, Xicanidad, the Nepantla state, and Afro-Futurist inspired ideals.

LAURA PHILLIPS
Small objects, big impact

LAURA Phillips took up the post of Coordinator of Collections & Exhibitions at Aanischaaukamikw Cree Cultural Institute (Canada) in September 2014. Prior to this, she was the Collections Manager at The Wolfsonian-Florida International University in Miami Beach, Florida. Laura has worked in museums, heritage and public sector organisations for over fifteen years: at the Pitt Rivers Museum, English Heritage's National Monument Record Centre and Bristol City Museum and Art Gallery (all in the UK). From 2010 to 2013, Laura was the Head of Museums Documentation for Qatar Museums Authority. Laura achieved her BA in Classical Studies at the University of Western Ontario. She undertook

a Post-Graduate Diploma in Professional Archaeology at the University of Oxford, and a Masters at the University of Bristol. Laura specialises in collections information management, museum documentation, collections management and is particularly interested in adapting museum practice to support emerging museums.

MARJORIE SCHWARZER
The Art Museum Chasm

MARJORIE Schwarzer co-directs the graduate museum studies program at University of San Francisco. In a former life, she was director of education at Chicago Children's Museum.

KAREN VIDÁNGOS
Critical Narratives of the Marginalized

KAREN Vidángos is a museum studies graduate student at the George Washington University in Washington, D.C., with a concentration in museum management. Her research on the under-representation of Latinos in the museum field began after working as museum shop supervisor in the Smithsonian and hopes to address this very issue as she writes her master's thesis on this topic. She currently interns in the communications and marketing department at the Hirshhorn Museum & Sculpture Garden.

WILLIAM CAMARGO
La Madre Chiquita

INFORMED by his parent's own immigration from Mexico in the early 80's, William Camargo explores notions of immigration, identity, and culture of the people he meets and is close to, through the medium of portrait photography and urban landscapes. He photographs in cities where immigrants from Mexico came to, his work has explored issues that have risen through the lack of representation in a cities where Latinos make a great number of the population and other cities in which an influx of Mexican immigrants have changed the very landscape of the city. In a current project he will amass a number of portraits and landscapes at

an attempt to create a photo archive of the Mexico/U.S relationship through the people who have immigrated to the U.S. He idolizes his subjects when most of them are belittled. His attempt is to show a humanization of the people and places he documents that are spoken about daily by political rhetoric.

TIM GORICHANAZ
The World in a Box

TIM Gorichanaz is a PhD Candidate in Information Studies at Drexel University, researching the philosophical and experiential aspects of working with documents. His dissertation explores artistic self-portraiture as a form of documentation. Tim earned a Master's in Spanish and Latin American Linguistic, Literary and Cultural Studies from New York University in Madrid, and he holds a Bachelor's from Marquette University in Milwaukee.

DENIZ BALIK
Compressed, Compact, Concise, and Refined: A Museum in Switzerland

DENIZ Balık holds a Ph.D. in Architectural Design. She is currently a Research Assistant of Architecture in Dokuz Eylül University. Her research focuses on criticism and theory in contemporary architecture, and cross-disciplinary studies of culture, society, media, art, and architecture.

MICHELLE DEZEMBER
Air, Water, and Earth: Lessons on Communication from a Museum in the Mountains

MICHELLE Dezember is the Learning Director at the Aspen Art Museum, where she oversees all aspects of education. She has served as the founding Head of Education at Mathaf: Arab Museum of Modern Art in Qatar, a museum educator in California and New York, and a Fulbright scholar in Spain. She holds a BA in Art History and BS Sociology from Santa Clara University and an MA in Museum Studies from the University of Leicester.

RONI PACKER
Open Table

RONI Packer is a painter, one that prefers paint and canvas to the pictorial space. Born and raised in Tel Aviv, Israel, Packer received her BFA, as well as BA in Humanities and Social Sciences in Israel. Currently she is an MFA candidate at The University of Illinois at Chicago. Packer's works feel their way from the politics and culture of her conflict-ridden home region, to the fears, anxieties and survival strategies of the individual, and back again.

BENJAMIN J. HRUSKA
Hong Kong Identity: Utilizing the Small to Challenge the Big

DR. Benjamin Hruska is a history instructor with Basis International School in Shenzhen, China. Before this he served as the Court Historian for the U.S. Department of Defense's U.S. Court of Appeals for the Armed Forces in Washington, D.C. He completed his PhD in Public History at Arizona State University in 2012, with his dissertation focusing on the changing memories over time for U.S. Navy servicemen in World War II. A portion of this dissertation was transformed into his first book, *Interpreting Naval History at Museums and Historic Sites*, published by Rowman & Littlefield last year.

MEIGHEN S. KATZ
The Fine Art of Reduction: Diminishment, Distance and Taylor's Panorama of Sydney

DR. Meighen Katz is a museum curator and early-career academic. She has lectured in urban history at the University of Melbourne, contributed to exhibitions at Museum Victoria and the Ian Potter Museum of Art, and writes on the interpretation of historical urban experience.

ALEXIS MIXON
Book Review—Museums, Heritage and Indigenous Voice: Decolonising Engagement

ALEXIS Mixon is a Museum and Exhibition Studies graduate student ta the University of Illinois at Chicago (UIC). Combining her degree in history and art history, she interns for Intuit: the Center for Intuitive and Outsider Art to preserve and to promote the artistic expression of marginalized groups. In her spare time she likes to read works by Zora Neale Hurston, to strategize new ways to fight the Power, and to watch any romantic comedy starring Meg Ryan.

ALEJANDRO T. ACIERTO
Selections from Focusing (Vol. II)

ALEJANDRO t. acierto is an artist and musician whose work is largely informed by the breath, the voice, and the processes that enable them. A founding member of Ensemble Dal Niente, Acierto holds an MFA from University of Illinois at Chicago, an MM from Manhattan School of Music, and a BM from DePaul University. More information can be found at his website: www.alejandroacierto.com

BENJAMIN L. LOCKE
Book Review—Bone Rooms: From Scientific Racism to Human Prehistory in Museums

BEN Locke is a graduate student in UIC's Museum and Exhibition Studies Program. He is interested in anthropology, urban history, and socially just indigenous representation in museums.

LILLIAN HUSSONG

Confronting the Holocaust: Immersive Counter-Memorials as Sites of Collective Memory

LILLIAN Hussong is a PhD student and Teaching Assistant at the Division of Global Affairs at Rutgers University. She previously earned a Master of Arts in Holocaust & Genocide Studies and a Bachelor of Arts in Historical Studies at Stockton University. Her work experience in genocide studies includes serving as an editor for H-Genocide, a member of the adjunct faculty at Stockton University where she has taught "The Holocaust" and "Non-Jewish Victims of the Holocaust," and a lecturer at the Kulanu School of Jewish Studies on "Selected Topics in Holocaust Studies."

JONATHAN KELLEY

The White Palace of the West

JONATHAN Kelley is a first-year graduate student in Museum and Exhibition Studies at the University of Illinois at Chicago. His primary areas of interest so far have been incarceration, atrocity, and tennis.

CALL FOR SUBMISSIONS 2018
Fwd: Museums Journal - "Alien"

MISSION

RECOGNIZING the need to critically transform museums, *Fwd: Museums* strives to create a space for challenging, critiquing, and imagining alternative modes of thinking and production within and outside of museums. This journal is produced by the University of Illinois at Chicago's Museum and Exhibition Studies Program.

THEME

IN response to the 2016 election and its immediate aftermath, the theme of our third issue is "alien." What does it mean to be "alien"? How can we unpack the term "alien" in the context of museums and cultural institutions?

Submission topics may include, but are not limited to:

» Politics of representation
» Museums as sites of social and political resistance
» Museums as sanctuary
» Migration
» Repatriation of cultural heritage
» Engagement/detachment
» Occupying digital spaces
» Alienated labor
» Terminology
» Centering marginalized groups
» Queering museums
» Experiences of alienation as a visitor

Fwd: Museums invites academic articles, essays, exhibition/book reviews, artwork, creative writing, experimental forms, and interviews. All submissions should follow the guidelines and relate to the journal's mission statement. We strongly encourage reviews and interviews and require all other submissions to connect to the third issue's theme, "alien." Scholars, artists, practitioners, and activists from all fields are welcome to submit.

» Deadline: January 5, 2018 by 11:59 pm (CT)
» Writing: Chicago style (footnotes and bibliography) English manuscripts of up to 2,500 words (with exhibition/book reviews up to 1,000 words, and interviews/profiles up to 1,500 words) as .doc, .docx, or .rtf files. There is no minimum word count. Submissions that exceed our word counts will not be considered. Manuscripts written in languages other than English may be considered.
» Visuals: Low resolution B/W and color images of original artwork in TIFF or JPEG format. If your submission is selected, we will request high resolution images of 300 PPI at print size.
» Submission form: https://tinyurl.com/FMJalien2018

FOLLOW US ON SOCIAL MEDIA:
https://www.instagram.com/fwd_museums/
https://twitter.com/fwdmuseums

LEARN MORE ABOUT UIC MUSE:
http://artandarthistory.uic.edu/uic_masters_muse

PLEASE email us at fwd.museums@gmail.com for further inquiries. Visit our website http://fwdmuseumsjournal.weebly.com/ for submission updates and more information on previous issues of *Fwd: Museums*.

CPSIA information can be obtained
at www.ICGtesting.com
Printed in the USA
LVOW05s0037020617

536493LV00014B/17/P

9 780980 230079